Windows and Mirrors

Leonardo

Roger F. Malina, series editor

Windows and Mirrors

INTERACTION DESIGN, DIGITAL ART, AND THE MYTH OF TRANSPARENCY

Jay David Bolter and Diane Gromala

The MIT Press Cambridge, Massachusetts London, England

First MIT Press paperback edition, 2005
©2003 Massachusetts Institute of Technology

This book was set in Adobe Garamond by Diane Gromala and The MIT Press.
Printed and bound in the United States of America.

Library of Congress Cataloging-in-Publication Data

Bolter, J. David, 1951–
 Windows and mirrors : interaction design, digital art, and the myth of transparency / Jay David Bolter and Diane Gromala.
 p. cm. — (Leonardo)
 Includes bibliographical references and index.
 ISBN-13: 978-0-262-02545-4 (hc. : alk. paper)—978-0-262-52449-0 (pbk. : alk. paper)
 ISBN-10: 0-262-02545-0 (hc. : alk. paper)—0-262-52449-x (pbk. : alk. paper)
 1. Digital communications. 2. Web sites—Design. 3. Digital art. 4. Multimedia systems.
 5. Human-computer interaction. I. Gromala, Diane. II. Title. III. Leonardo (Series)
 (Cambridge, Mass.)
TK5103 7.B65 2003
700'.285—dc21 2003051256

10 9 8 7 6 5 4 3 2

Contents

Series Foreword

The relationship of digital art to innovation in the practice of design is the subject of *Windows and Mirrors: Interaction Design, Digital Art, and the Myth of Transparency* by Jay David Bolter and Diane Gromala. Centered on a conception of art practice that emphasizes the function of experimental forms, Gromala and Bolter postulate that digital art can directly inform the trajectory of interaction design. By shaping a discourse around issues of artistic practice, *Windows and Mirrors* is an analysis of the material engagement and desire to define the computer as media.

According to their analysis, a conception of the computer as media runs in direct contradiction to structuralist orientations offered forth by engineers for whom the objective of digital transparency defines the interactive experience. In contrast Gromala and Bolter's analysis points to a continuously emerging media that attempts to define itself and is therefore visible and reflective of the user. The focus of *Windows and Mirrors* is the SIGGRAPH 2000 Art Show. ACM SIGGRAPH Conferences began in 1974 to enable presentation and discussion of the latest research advancements in computer graphics and interactive techniques. The conference and accompanying trade show quickly grew into one of the world's most prestigious venues dedicated to envisioning the future of digital imaging. Conference organizers recognizing the need to address the human element expanded their program to include the arts and hosted the first Art Show in 1981. Over the next two decades hundreds of artists participated in this unique event in which artworks, research and technology innovation create a framework for envisioning the future. Gromala and Bolter's selection of the SIGGRAPH 2000 Art Show draws attention to a specific moment of transition as we entered a new millennium. Theirs is a unique collaboration. As Chair of the SIGGRAPH 2000 Art Committee, Diane Gromala offers important curatorial insight while Jay David Bolter, a historian and theorist of digital technology, provides an outside perspective, examining the implications of the selected artworks on the field of interaction design.

The Leonardo Book Series is proud to include *Windows and Mirrors: Interaction Design, Digital Art, and the Myth of Transparency*.

Joel Slayton

Acknowledgments

The "we" of this book (the coauthors) represents two perspectives on the SIGGRAPH Gallery. One of us was involved in every step of the design and execution of the gallery; the other was an engaged outsider. Diane Gromala was the chair of the SIGGRAPH 2000 Art Committee and therefore had primarily curatorial responsibility for the gallery. (David Okula also made important contributions to the design of the gallery.) Jay David Bolter, meanwhile, witnessed the evolution of the gallery as he worked with Gromala in the Wesley Center for New Media at the Georgia Institute of Technology.

Our backgrounds have proved to be complementary (or perhaps contradictory) in productive ways. Gromala had had long experience as a digital artist and designer, to which she added a knowledge of media and critical theory. Bolter had been a historian and theorist of digital technology, whose work in hypermedia had led him to a growing appreciation of the computer as a new expressive medium. We have subsequently cotaught courses on digital, visual design in the graduate program at Georgia Tech, in which we combine productive theory with critical practice.

For each of us, the gallery was a reflective experience, but in different ways. Gromala knew each exhibit so well that she was able to reflect on their effects as she forged her vision of the whole gallery as a collective experience. Bolter was able to consider each of the pieces in turn and the gallery as a whole, when he visited the working gallery in July 2000. This visit helped him to reflect on the relationship of digital art to the larger design and human-computer interaction communities.

The Art Gallery Committee, who worked with Diane to plan and stage the exhibit, included Deena Elisabeth Eber (Bowling Green State University), Mirtha Ferrer (Georgia Institute of Technology), Ian Gwilt (Wanganui Polytechnic), Saoirse Higgins (ArtHouse Multimedia Centre), David Okula (Space Guru), Lily Shirvanee (MIT Media Lab), and Noah Wardrip-Fruin (New York University). The committee was assisted by the jury, including Steven Dietz (Walker Art Center), Thecla Schiphorst (Simon Fraser University), Andrew Glassner (consultant), and Marla Schweppe (Rochester Institute of Technology).

In addition to the committee, we have many people to thank for helping to make this book possible: Frances Hamilton, Lauren Keating, and Lily Shirvanee. We thank those

who read and critiqued portions of the manuscript, including John Bowes, Amy Bruckman, Christine Golus, Blair MacIntyre, Gretchen Schiller, Tom Rieke, Chris Shaw, and Teal Triggs. Their comments were extremely helpful, even when we weren't wise enough to follow all their advice. Thanks to the talent, help, and support of The MIT Press, especially Douglas Sery, Katherine Innis, Sandra Minkkinen, Beverly H. Miller, Erica Schultz, and Yasuyo Iguchi.

We thank our families as well: Christine deCatanzaro, David Joseph Bolter, and Chris Shaw, who provided advice and support throughout the writing of this book. We appreciate the contribution of JavaMonkey as well, which provided excellent coffee and an ideal space for writing and collaboration.

We are grateful to the following artists, designers, scholars, and friends for their kind permission to reprint graphics: figures 1.1–1.6 (Camille Utterback and Romy Archituv); figure 1.8 (Lubalin family); figures 2.1 and 2.2 (Daniel Rozen); figure 2.10 (Zuzana Licko); figures 3.1–3.4 (Tiffany Holmes); figure 3.5 (Wolfgang Weingart); figures 4.1–4.4 (Mark Billinghurst, Rob Blanding, Winyu Chinthammit, Tom Furness III, Nick Hedley, Hirokazu Kato, Lori Postner, Ivan Poupyrev, and Lily Shirvanee); figure 4.5 (Kathleen Brandt); figure 4.6 (Cameron McNall, Shane Aker, Doren Garcia, Jim Gayed, David Hutchins, Gareth Smith, and Jackie Stewart); figure 5.1 (Jeff Gomperz, Prema Murthy, and Eugene Thacker); figure 5.2 (Michael Hart); figure 5.3 (Elliott Peter Earls); figure 5.4 (Ranio Ho); figure 6.1 (Sponge: Sha Xin Wei, Chris Salter, Laura Farabough, Maja Kuzmanovic, Evelina Kusaite, Cynthia Bohner-Vloet, Sam Auinger, Joel Ryan, Ozan Cakmakci, Kristof Van Laerhoven, Els Fonteyne, Walter van de Velde, Adam Lindsay, and David Tonnessen); figures 6.2–6.5 (Larry Hodges); figures 6.6–6.7 (Blair MacIntyre); and figures 7.1–7.5 (Michael Mateas, Steffe Domike, and Paul Vanouse).

Unless otherwise indicated, all the sites referenced in this book were visited and working on or about July 1, 2002.

Finally, we acknowledge the work of the following critics and theorists. Readers (and especially reviewers of our book) all have their favorites and are likely to complain that we are ignorant of this or that key idea. We are no doubt ignorant of many important ideas, but we are acquainted with the contributions of the theorists and theories listed below. We choose not to discuss them, because this is a book about the craft of and the material

engagement with digital art and design, and we believe that the theoretical literature often strays too far from practice to be useful for our purposes:

Richard Dawkins and memes
Deleuze and Guattari and rhizomes
Donna Haraway and cyborgs
Heidegger and enframing
The Frankfurt School and the culture industry
Lacan and the mirror stage
Baudrillard and simulacra

Windows and Mirrors

Introduction (but really, you should read this)

In 1998 in *The Invisible Computer,* Donald Norman told us that computers as we know them are going to disappear. We'll continue to use computers, of course, but they will disappear from view as they are absorbed inside "information appliances." Norman drew an analogy to electric motors in the early twentieth century. When the technology was first marketed, consumers bought a very visible electric motor with attachments to accomplish various tasks—for example, to power a vacuum cleaner. But soon the motors were built into the appliances. No one any longer thought of the machine as an electric motor with an attachment to clean floors; instead, they thought of it as a vacuum cleaner, which contained a motor as a component. Norman believes that computers will evolve in this same way into information appliances, such as electronic calendars, cell phones, and portable e-mail readers. We won't care much that there is a digital processor inside these appliances; we *will* care that each appliance accomplishes a task for us. Norman's argument seems convincing when we look around at all the devices, from personal digital assistants (PDAs) to automobiles, that depend on computer chips. Still, Norman is telling only half the story. Our book is meant to tell the other half.

This is a book specifically about digital art, but it is written for digital designers and technologists in general: Web designers, educational technologists, graphic designers working with and in digital forms, interface designers, human-computer interaction (HCI) experts, those who are laying out the future of digital media for business and entertainment, and anyone interested in the cultural implications of the digital revolution. We describe in this book what digital art has to offer to this vast community.

Digital art shows that the computer is not becoming invisible in our culture, as the electric motor did. We don't want computers to disappear. Although processors are being buried in all sorts of devices, computers continue to fascinate us. We continue to be exhilarated by and sometimes frightened of what digital technology is doing, and we are tantalized by the prospect of what it might do in the future. It is the task of digital art to fascinate, exhilarate, and sometimes provoke us. Appliances, on the other hand, don't fascinate us; they brown our toast.

We are talking about two competing visions of digital technology: the pragmatic vision offered by Norman and other HCI experts, for whom computers *are* information appliances, and the vision offered by digital artists and interaction designers. They are com-

peting in the sense that each vision is an attempt to convince our culture at large. The differences in these visions emerge quite clearly when we look at the most popular, the most exciting, and in some ways the most disappointing contemporary manifestation of digital technology: the World Wide Web. Let's start with a parable.

The Structuralists and the Designers

The Internet once belonged exclusively to the Structuralists, a community composed mostly of graduate students and professors in computer science, who seldom ventured outside their cubicles. This closely-knit community had its own ethics and languages (such as C). Their culture was highly developed in mathematics but not in art.

Around 1990, one of these Structuralists, Tim Berners-Lee, had an idea for a new service that would run on the Internet, a global hypertext system he called the World Wide Web. There had been other hypertext systems before this, most of which had worked only on stand-alone computers. Berners-Lee's brilliant idea was that the links of one hypertext could point to information stored on other servers connected to the Internet. But his hypertext system was limited largely to verbal representation: each page could display only ASCII text along with links. This was adequate for the uses that Berners-Lee foresaw, because he wanted a system that would help scientists share drafts of their papers and other information. The World Wide Web grew slowly in its first years, precisely because it served this limited audience.

In 1993, another Structuralist, Mark Andreessen, and a colleague produced Mosaic, the first graphical browser for the Web. At the same time, he introduced a new tag—the in-line image tag—which allowed static images to be integrated into the text of the Web page. This apparently small improvement had enormous consequences, because people outside the Structuralist community began to see how the Web might be used to provide information and entertainment to a vast audience beyond the scientific world. They began to imagine what we now call e-commerce.

That's when the Designers started to invade the Internet. Although this tribe was less homogeneous than the Structuralists, many of them were trained as graphic designers for print, and they brought the skills and assumptions of graphic design to the Web. They knew how to weave together words and images in order to communicate in the two-dimensional space of the printed page. They assumed that a Web site could function like a newspaper or magazine as a form of visual communication. Some Designers came to Web design because

they were attracted by the potential of this new form. Others invaded the territory of the Structuralists as mercenaries, paid by clients who wanted to colonize this new realm for advertising.

The Designers soon mastered the Structuralist language, html. They considered this language primitive, however, because it did not provide enough control over the look of the Web page. The reason was that, in keeping with their view of how information should be organized, the Structuralists had designed html to describe the structure (paragraphs, lists, links) but not the appearance of the page. The appearance—the Structuralists believed, according to their ethic of technological democracy—should be determined by each user.

This was the great, almost religious difference between the Structuralists and the Designers. The Structuralists were separatists, believing that form and content could and should be separated. For them, a Web site is a pipe through which content flows to the user. They opposed elaborate visual design, which they thought impeded the flow of information. The Designers, on the other hand, were unitarians, who believed that form and content could not be separated: that a Web page communicates its message through the careful interplay of words and images. For the Designers, a Web page is an experience, and they wanted complete control over it, just as they had enjoyed (more or less) complete control in print. So the Designers kept pressing for more html tags that would give them that control.

The struggle to define the Web continued throughout the 1990s. For example, the Designer David Siegel (from whom we have taken the term *structuralist*) wrote in his influential book *Creating Killer Web Sites* (1997), "I believe design drives the user's experience. . . . Who cares how great your content is if people aren't attracted to it or don't find it pleasurable to read?" (8).

As late as 2000, HCI expert and Structuralist Jakob Nielsen wrote in *Designing Web Usability,* "Ultimately users visit your website for its content. Everything else is just the backdrop. The design is there to allow people access to the content. The old analogy is somebody who goes to see a theatre performance: When they leave the theatre, you want them to be discussing how great the *play* was and not how great the costumes were" (99). Nielsen has become the champion of what might be called the Structuralist Reformation, pursuing with a puritanical zeal what he regards as the exuberance of the Designers.

Nielsen believes that the Web is for business, not pleasure: it should be a transparent channel for information transfer. He is literally an iconoclast, arguing that graphics are greatly

overused on the Web (they slow download time). He would bar the use of Flash from Web sites. For Nielsen, the most efficient design is one that becomes invisible and leaves the user alone with the information content, and clearly that content is typically text rather than an image. Designers like Siegel believe that Web pages are visual (and potentially auditory) experiences. Static and now moving images are not "window dressing" that slow download time; rather, they are essential to the communicative experience.

Nielsen's book and articles are widely read and discussed. For better or worse, however, the Designers seem to be winning the battle in cyberspace itself. Nielsen himself admits that the vast majority of Web sites are badly designed—that is, they don't follow his prescriptions. There are more images, more digitized video and audio, more animation on the Web every day. Designers like Siegel would agree that sites are often (usually?) poorly designed. For them, the problem is not that the sites use too many images, but rather that they use these images poorly and so fail to provide a compelling experience for their users.

The visible computer
The debate between the Structuralists and Designers over the World Wide Web is part of a struggle to define new media design and, in a larger sense, the significance of digital technology for our culture. While Jacob Nielsen and Don Norman might (or might not) object to the name, they represent the Structuralist position with authority. Nielsen tells us that Web pages should be transparent vehicles of information delivery. Norman tells us that the computer will be absorbed into a series of smart information appliances. They are not altogether wrong. Sometimes we do want our Web pages to provide the quickest route to a specific fact, and we are already surrounded by information appliances, especially cell phones.

For our current culture, however, the term *appliance* doesn't describe computers very well. Computers don't feel like toasters; they feel much more like books, photograph albums, or television sets. For us today—and it's a realization that our culture has made gradually over the past thirty years—the computer feels like a medium. It is providing us with a set of new media forms and genres, just as printing, the cinema, radio, and television have done before. These digital media forms stage experiences for us.

As producers and as users of digital technology, we don't want our computers to disappear, any more than we want books, films, or paintings to disappear. As producers and as users, we often want to be aware of the medium in order to understand the experience that it

is staging for us. For that reason, this book could be subtitled *The Visible Computer.* As producers, we must master techniques to render digital media transparent to the user, but we must also render the media visible to and reflective of the user. Making digital artifacts requires both perspectives. As we show in the following chapters, every digital artifact oscillates between being transparent and reflective. The mistake that Nielsen and

Every digital artifact oscillates between being transparent and reflective.

Norman make is to assume that the single goal of all design is to make the interface transparent, when in fact the goal is to establish an appropriate rhythm between being transparent and reflective. This is a common error in mainstream interface design and HCI today. Despite evidence of the popularity of experiential Web sites, computer designers and HCI experts still suppose that the best interface is always "clear," "simple," and "natural." As we shall see, all of these are variations on the theme of the disappearing computer.

How to read our parable, or what we are *not* saying

This book will be misunderstood. In a vain effort to prevent misunderstanding, we would like state at the outset: we are NOT saying that the computer and information scientists, who, after all, built the Internet and created the World Wide Web, are foolish or naive. And we are not claiming that visual designers are innately superior. The Structuralists represent an important vision of the world as information to be organized and presented to users in the most efficient way possible. Their vision is not wrong, but it is incomplete. (In fact, some of the Structuralists themselves are beginning to acknowledge the need for a broader vision. Norman is now studying the importance of aesthetics for design, as he indicates in "Emotion and Design," published in *Interactions,* 2002.)

Furthermore, we are not denying that there is a difference between art and more pragmatic forms of design. The distinction between visual art and graphic design, for example, is a century old. We believe, however, that in one sense, digital art can be understood as a form of interface design.

The significance of digital art

The assumption that the computer should disappear needs a strong corrective, and in this book, we look to digital art to provide that corrective. We will examine some compelling

recent works, taken from the art gallery at the SIGGRAPH conference at the turn of the mil-
lennium. These works cannot be dismissed as eccentric reactions to digital technology or as
"personal expressions." We should instead think of them as radical experiments in digital
design—experiments by people with a wide variety of backgrounds in art and technology
who have thought deeply about the relationship between digital technology and the user.
Such digital art can be the purest form of experimental design.

Digital art is relevant for information architects, creative managers who are building
Web sites, usability specialists testing productivity software, computer scientists imagining
new applications in mixed reality and ubiquitous computing, and those seeking to create new
forms of digital entertainment. That relevance is proved by the fact that one of the most pres-
tigious computer conferences welcomes this art into its midst. These works are not meant to
deliver some benign information content and then disappear from our consciousness. Instead,
they engage us in interactive experiences in which it is meaningless to try to separate form
and context. Rather than castigate the Structuralists, we want to convince them that digital
art can help all information technologists achieve their goal of effective design.

Chapter 1. TEXT RAIN

THE DIGITAL EXPERIENCE

To design a digital artifact
is to choreograph
the experience that the
user will have.

If we only look *through* the interface,

we cannot appreciate the ways in which

the interface itself shapes our experience.

The Art Gallery of SIGGRAPH 2000

SIGGRAPH 2000 was a carnival for the twenty-first century. Its distant predecessors were the medieval and Renaissance trade fairs of Europe, where people crowded into a muddy town marketplace to gawk at tables of exotic goods (cinnamon and silk), to be entertained by singers, jugglers, players, and animal acts. The delights of SIGGRAPH 2000 were more high tech; there were no dancing bears. For the conferees of SIGGRAPH 2000, technology itself was the attraction: the latest releases of Photoshop and OpenGL; the fastest new texture-mapping hardware from SGI; the newest games for the Sony Playstation 2. All these attractions were collected in a maze of booths in the enormous, refrigerated halls of the Morial Convention Center in New Orleans.

The conferees came not only to see the newest technological toys but also to discuss the future. For, unlike Comdex, the Las Vegas extravaganza of electronic consumerism, SIGGRAPH is an academic conference as well as a trade show. In the technical sessions, conferees considered technologies yet to be released. Academic computer specialists and industry researchers met to review work on subjects like the psycho-physiological models of shading and lighting, the modeling of snow, the animation of clouds, and non-photorealistic virtual reality. Unlike other academic conferences, SIGGRAPH has long recognized that digital art can contribute to this discussion—that digital art too is technology yet to be released. The Art Gallery has been a part of SIGGRAPH since the 1980s, and the

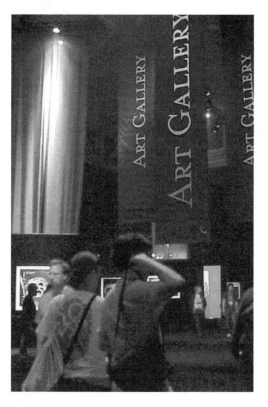

Figure 1.1
The Art Gallery of SIGGRAPH 2000.

gallery at SIGGRAPH 2000 was the largest and most varied in the history of the conference, exhibiting the work of sixty leading digital artists.

Hall D, which alone seemed large enough to assemble the space shuttle in, housed the Art Gallery (figure 1.1) as well as the Emerging Technologies exhibit. You might have found it difficult to decide where the art ended and the emerging technologies began. Like the digital art, many of the Emerging Technologies exhibits provided visitors with interactive experiences. Like the Emerging Technologies exhibits, installations in the Art Gallery were experiments in design. The most visible, and in some ways the most important, part of any digital application is its interface—the face that the application presents to its users. And digital art is all interface, defined entirely by the experience of its viewing or use. That is why digital art can provide such a clear test of the possibilities and constraints of digital design: it fails or succeeds unequivocally on the strength of its interface.

Digital art can provide the clearest test of the possibilities and constraints of digital design.

In the following chapters we tour the Art Gallery of SIGGRAPH 2000, stopping to examine a few pieces closely, because this tour has a specific purpose. We want to ask of each piece: What does this work have to offer to the digital design community in general? What lessons can we carry from this work over into other applications, other domains of digital design? Because each piece is a realization, an embodiment of radical design, it will embody the following three points:

1. **The computer has become a new medium (a new set of media forms).**
2. **To design a digital artifact is to design an experience.**
3. **Digital design should not try to be invisible.**

Since the 1970s, it has become increasingly clear in our culture that the computer and related digital technologies are media technologies and support a range of new media forms. Media forms are not just channels for information, they also provide experiences. Furthermore, in every digital artifact, from spreadsheet to video game, the physical shape, the interface, the look and feel are part of the user's experience. Every digital artifact needs at times to be visible to its user; it needs to be both a window and a mirror.

TEXT RAIN

It's July 25, 2000, and the gallery is crowded with visitors. An installation that everyone visits sooner rather than later is *TEXT RAIN,* created by Camille Utterback and Romy Archituv. *TEXT RAIN* consists of two large parallel screens; one features projected video, while the other serves as a backdrop. These two screens form a corridor about ten feet wide within the gallery, and no one passes through that corridor without glancing up at the screen, slowing, and then stopping, at least briefly, to take part in the show. As the visitor immediately discovers, she herself becomes the show, when her face and figure are caught by the video camera and projected on the screen in black and white. At the same time, a rain of colored letters falls steadily from the top of the screen. Wherever the letters come in contact with the viewer's image, they cease to fall. Whenever the viewer moves, the letters that had collected resume their fall. Visitors instantly want to play, making visual and verbal patterns by holding the letters in their hands or along their arms (figures 1.2 and 1.3). They hold up boards or sheets in order to catch the letters and even make them rebound (figures 1.4 and 1.5).

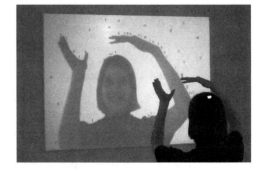

Figure 1.2
Camille Utterback and Romy Archituv, TEXT RAIN: *Catching the falling letters.*

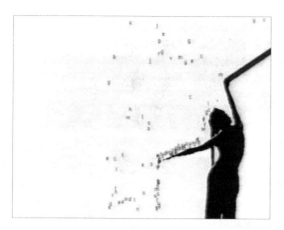

Figure 1.3
TEXT RAIN: *A dancer channels the letters with her body.*

TEXT RAIN is not simply an expression of the artist's personality. (That romantic notion doesn't fit digital art well.) Rather, the experience of this piece comes from the interaction of the viewers with the creators' design. *TEXT RAIN* is as much an expression of its viewers as of its creators; it is what the viewers make of it. Without them, the piece is incomplete, for there is nothing on the screen but the falling letters. In fact, *viewers* is not an entirely adequate term; they are participants or users at the same time. *TEXT RAIN* is a text that its viewer-users help to create, a text that they write in the process of reading. Like the other digital installations in the gallery, *TEXT RAIN* is about the process of its own making.

The letters of the text come from the poem "Talk, You" by Evan Zimroth (1993). If you cup your hands, you sometimes manage to capture a whole word or a short phrase. The word or phrase belongs to the original poem, if the letters manage to stay together during

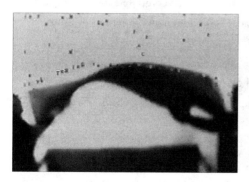

Figure 1.4
TEXT RAIN: *Using a sheet to catch . . .*

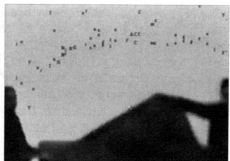

Figure 1.5
TEXT RAIN: *. . . and toss the letters.*

Figure 1.6
TEXT RAIN: *Making a kinetic poem.*

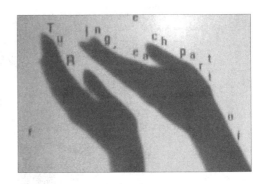

their fall. When one or more letters are lost
or the letters of another word intervene,
TEXT RAIN becomes a kinetic poem—one
that re-forms itself before your eyes.
Turning could become *tuning, limb, limbo.*
Often, the letters that rain down offer only nonsense, but sometimes they make just enough
sense to encourage the viewers to find meaning. "TuninGear und too" or "ym for limbs" or
"Im faces" could be phrases from James Joyce (Figure 1.6).

In this way *TEXT RAIN* comes to mean what the viewer-user wills it to mean.
Digital works like *TEXT RAIN* make us playfully aware of our relationship to our technology,
and they suggest that we can assert some degree of control over the relationship.

TEXT RAIN not only invites its participants to make meaning; it puts them on video
as they do so. Other visitors to the gallery can see them holding up their arms and smiling, and
they can see the images on the screen, which explain the participants' funny gestures. The
behavior of the participants brings other visitors over, who then become participants themselves.
TEXT RAIN is a poem and a video program at the same time. As an experiment in the future
of digital technology, it suggests that that future belongs to presentation and representation.

In our digital culture, we are indeed coming to value computers for their capacity to
present and represent. We have known for decades that computers can represent numbers
and texts, but now we know that they can also present images and sounds. Using a computer
has become a multimedia experience—an experience so compelling that we in the industrial-
ized world now surround ourselves with digital devices. In the past, we were reluctant to
acknowledge that computers offered us such experiences. Only teenage boys and geeks were
allowed to admit that digital technology could be fun or exciting. For the rest of us, comput-
ers were supposed to be "good for something." However, just like films, CDs, and books,
what digital artifacts are often good for is to stage experiences for their users.

HCI expert and cognitive scientist Donald Norman tells us that as computers
become smaller and more portable, they are morphing into information appliances. Although

it is certainly true that digital technologies are conveyors of information, the term *appliance* is too limiting. We do not call books, still cameras, or movie cameras "appliances." We do not simply apply computers to tasks of information storage and retrieval, any more than we use books or television strictly for that purpose. Books, televisions, and computers stake out a cultural territory that is more varied and more mysterious than refrigerators. That's the territory that *TEXT RAIN* and the other installations of SIGGRAPH 2000 are exploring. Each installation calls its participants into an active relationship, asking them to perform rather than merely to view.

Brenda Laurel understood the performative and representational power of the computer when she wrote *Computers as Theatre* (1991). She argued that we should design computer applications not only to be used, but to be performed and experienced. But Laurel put too much emphasis on one rather specialized media form, the theater. In fact, the computer is not only a new stage for theatrical performance; it can also be a new cinema, a new television, and a new kind of book. The computer does not fuse all its representations into a single form, but presents them in great variety. If there was ever a technology that did not have a single essence, it is the digital computer.

In its fifty-year history, the computer so far has been a calculating machine, an electronic brain, a filing cabinet, a clerk, and a secretary. If we trace that history briefly, we can see how the computer has now become a medium, or rather a growing set of media forms.

The computer becomes a medium (a new set of media forms)

It's 1949. Depending on your definition of a computer, there are three or four such machines in the world, whose names sound like villains in Superman comic books: ENIAC, EDSAC, BINAC. These machines are used almost exclusively to do complex calculation for military and civilian scientists and engineers. Computer pioneer Howard Aiken is reported to have told the U.S. Bureau of Standards that the world would only ever need five or six computers like the ENIAC.

The computer did not start out as a medium. In the 1940s, when the brilliant and elegant John von Neumann, the brilliant and eccentric Alan Turing, and many others were designing the first programmable computers, they were *not* defining a new medium. They were building super-fast calculating engines to solve problems in science and engineering. Their work was

funded by the U.S. and British governments as part of the effort to win World War II and then to ensure the advance of technology after the war. Even at that time, however, von Neumann and Turing understood their machines as something more—as "symbol manipulators." It didn't matter whether the symbols were numbers, words, or the elements of any logical calculus. The computer could take these inputs, apply the rules of logic, and produce new patterns as output.

In the late 1940s, when he was working at Manchester University and musing on the significance of the first computers, Alan Turing came to believe that the essence of human thought is symbol manipulation. Turing was in many ways a stereotype of the British mathematical genius, lost in thought and unconcerned with appearances: he bit his nails, went out without his tie, and rode a bicycle whose chain derailed with mathematical regularity (Hodges 1983). During World War II, Turing had helped to build and use the mechanical Bombe and the electronic Colossus to decrypt messages from the Germans' Enigma coding machines, so he knew that a computer could function as a technology for transforming and transferring messages—that is, as a medium. But he went in another direction, appropriate for an introverted genius, and became convinced that the digital computer was not a medium but a mind. For Turing and others who followed him, the computer should not just be a channel for human messages; it should be a thinking machine, capable of producing its own messages.

It's 1954. The U.S. economy is already spending $10 million a year on computer hardware (Cortada 1997, 32). The machines are beginning to be used not only for military and scientific research, but also for large-scale bureaucratic tabulation and business data processing. On election night in November two years earlier, the UNIVAC computer had predicted a landslide win for Dwight Eisenhower, suggesting that computers can manifest greater political savvy than the pollsters, who were predicting a close race.

Turing became the patron saint of the artificial intelligence (AI) movement. Following Turing, AI specialists, including John McCarthy and Marvin Minsky, argued that computers could make that ultimate leap over the wall that the French philosopher Descartes had erected between the mind and the body. They believed that computers were physical machines that could exhibit mind, the very idea that Descartes had thought impossible. These enthusiasts proceeded to frighten and fascinate us with this vision for almost half a

century, although even today, no machine can come close to passing the Turing test. Sadly for AI enthusiasts, 2001 has come and gone, and there is no HAL. Yet the idea of the computer as a symbol manipulator was and remains powerful. All the scientific and engineering uses of the computer, the business information systems, the databases and text archives, and more recently the spreadsheets and word processors in personal computers, are expressions of the computer as symbol manipulator. Throughout the last half of the twentieth century, the enthusiasts kept insisting that the essence of both human and machine intelligence was symbol manipulation—that there was, in fact, no essential difference between human beings and computers. And because of the way we used the computer in these decades, they made some sense. It was easier to think of the computer as an ersatz human being than as a medium like print, radio, film, or television.

It's 1962. There are 10,959 computers in the world (Cortada 1996, 70). In the following decade, the first time-shared computer systems will allow some lucky programmers at MIT and elsewhere to input their programs "interactively"—by typing them into a text editor. Nevertheless, many still fail to see the computer's potential to store and transmit even textual information.

A few voices were suggesting that the computer was a medium, but it took us decades to hear them over the noisy claims of the AI enthusiasts. No one listened in the early 1960s, when a young humanist, Ted Nelson, began to argue that the computer made possible a new kind of reading and writing that he called "hypertext." Douglas Engelbart got a much better reception in 1968 when he gave a masterful demonstration of his NLS (oNLine System), which included collaborative word processing, data file sharing, teleconferencing, and hypertextual linking. His audience of a thousand computer professionals was overwhelmed. J. C. R. Licklider and Robert Taylor were moved by NLS to write, "In a few years, men will be able to communicate more effectively through a machine than face to face" (Licklider and Taylor 1999). Their article, "The Computer as a Communications Device," written in 1968, was one of the first to label the computer as a medium. Licklider and Taylor had seen a very early version of the future, however; Engelbart was still years ahead of his time. In order to make the computer a communications medium for our culture as a whole, two technologies had to be developed and put into widespread use: electronic networks and the personal computer.

It's 1979. The number of personal computers in the United States already exceeds 500,000 (Cortada 1997, 33). Two college dropouts are building and marketing a microcomputer they call the Apple. The networking of universities and corporate research centers, which began around 1970 as the ARPANET, continues. College students at Duke and the University of North Carolina are devising a protocol called Usenet to allow people to subscribe and contribute messages to newsgroups.

Licklider at the Advanced Research Projects Agency in the Defense Department supported the development of the wide-area network, the ARPANET, which eventually led to the NSFNet and the contemporary Internet. Robert Metcalfe and others at Xerox Palo Alto Research Center (PARC) in the 1970s created the software and hardware for local-area networking, called Ethernet. Meanwhile, Alan Kay and his team at Xerox PARC were inventing the personal computer, which Kay called the Dynabook, or "personal dynamic medium" (Hiltzik 1999). Kay had no doubt what the computer was when he wrote, "Although digital computers were originally designed to do arithmetic computation, the ability to simulate the details of any descriptive model, means that the computer, viewed as a medium itself, can be *all other media* if the embedding and viewing methods are sufficiently well provided" (Kay and Goldberg 1999). Kay was claiming that the computer was the ultimate medium and could make all other media obsolete. Using his Dynabook, we could create, edit, and store texts; we could draw and paint; we could even to compose and score music.

What Kay and his colleagues actually produced was the Alto (figure 1.7), an "interim" Dynabook that could perform all these wonders in some form. But the Alto was a research machine, which only the workers at Xerox PARC and some lucky students at the Jordan Road Middle School in Palo Alto ever got to use. In order to convince the rest of us, the Dynabook had to come into the hands of millions of users, and Steve Jobs added that necessary element when he marketed

Figure 1.7
The Alto computer, a "personal dynamic medium" of the mid-1970s. Courtesy of Xerox Palo Alto Research Center.

Figure 1.8
Herb Lubalin, computer-controlled graphic design
from the 1970s.

the Macintosh computer. The graphics and sound capabilities of the Macintosh were the key to convincing us that the computer was a medium. At that time when someone said the word "medium," we thought first of television, film, and radio. Now, as the computer screen began to look and act like a television screen and as its speakers began to play music or even speak words, we saw the computer itself in a new way.

Computer specialists had been exploring the power of the computer to display, manipulate, and animate images since the 1960s, but a popular audience for their electronic images developed only later. American culture first came to appreciate computer graphics in such movies as *Star Wars* (1977) and then on television. Meanwhile, graphic designers began to use computer-controlled photocomposition to create layouts in magazines and newspapers (figure 1.8).

It's 1989. There are almost 14 million computers in American homes; 75 million Americans use a computer at home, at school, or at work (Cortada 1997, 33). Now eight years old, the IBM PC has established the word processor and the spreadsheet as indispensable business tools. (And as a result, typewriter sales are declining for the first time in a hundred years.) For millions of business users, the computer is now unquestionably a medium for words and numbers. For a smaller group of designers and educators, Apple is offering the first computer that is both a tool for visual design and an artifact of visual design.

With the Apple Macintosh computer, users had at first primitive and then increasingly sophisticated tools with which to create their own graphics. The computer became a

medium when these tools and practices became widespread and the rhetoric of their enthusiasts became plausible. That rhetoric moved from articles in journals to advertisements in newspapers and on television, as communications and computer corporations began to announce (prematurely) that the computer was replacing the printing press. (It is amazing how seductive the rhetoric of prediction is. As recently as 2000, in *Designing Web Usability,* Jakob Nielsen was predicting that computers would replace printed books by 2007.)

It's 1993. With its Windows operating system, Microsoft ensures the success of the graphical interface that Xerox and Apple pioneered. The supporters of the DOS interface are left to join the Society for Creative Anachronism. Meanwhile, when Marc Andreessen shows the "inline image" tag to Tim Berners-Lee, the World Wide Web becomes a medium of visual design that will soon rival magazines and books.

The World Wide Web was the final element, creating in the 1990s an audience of millions of viewer-users for the digital experiences that networked computers had to offer. The creator of the Web, Tim Berners-Lee, had originally conceived of it as a textual medium, a global hypertext of words. But a few years later, Mark Andreessen and his colleagues devised the graphical Web browser and placed images and text together on a Web page for the first time. Within a few more years, it had become apparent that the computer could reconfigure and re-present much of the information and experience that our culture had previously located in books, newspapers, and magazines, in radio, in films, and on television. The computer was now unquestionably a medium, and it seemed hard to think of it as anything else.

At that point, our fears and fantasies changed too. For decades, AI specialists had fascinated us with the notion that the computer would change what it means to be human. (In 1984, Sherry Turkle summed up their vision in her book *The Second Self.*) If the essence of human thought was symbol manipulation, then it seemed inevitable that computers would eventually outthink us. In the 1960s, 1970s, and 1980s, philosophers, psychologists, and computer scientists argued furiously over what computers could or could not do—whether there was some human essence that computers could not duplicate. The argument was never settled, though, because it was a debate over cultural constructions. Collectively as a culture, we decide how computers are going to be used—whether as aids to human intelligence (calculators and word processors), replacements for human intelligence (AI applications), or expressive

Figure 1.9
Virtual reality headset (photograph: Ted Esser).

media. What happened was that we lost interest in the AI question as we changed our idea of what computers are for.

Computer graphics became more compelling to us than numerical analysis and logic programming. Although computers were still used to perform physics calculations, tend databases, write memos and letters, and control industrial processes, these applications had become routine. What caught our imagination now was the computer as a perceptual manipulator—as a graphics engine to make images move and as a MIDI (Musical Instrument Digital Interface) controller for sound. Virtual reality (VR) replaced AI in our digital dreams and nightmares, and in VR the old debate about technology and humanity was again redefined. The supporters of AI had insisted that human beings, like computer programs, were information processors. The VR enthusiasts now offered a different definition of human identity that emphasized the senses rather than abstract information processing. They suggested that to be human was to be a bundle of perceptions, a moving and malleable point of view, just what we feel when we are wearing a VR headset. The most compelling computer experience changed. It was no longer playing chess against an AI program like Deep Thought; instead, it was the experience of being immersed in a virtual world (figure 1.9).

The Internet was the other technology that changed our view of computers. The Internet realized the vision of Nelson, Engelbart, and Licklider for the computer as a node in a (potentially) global network. With the coming of e-mail and the World Wide Web, a standalone computer, one without a network address, now seemed incomplete. Digital devices, from desktop computers to palmtops, became portals to connect us with other people and devices. The texts we typed into our word processors no longer had to be printed out and delivered to readers in the traditional form of ink on paper. Now the computer itself was a medium of both creation and almost instantaneous publication. Now there were chatrooms, MOOs, and applications for instant messaging, which carried with them the excitement and potential danger of communicating with people around the industrialized world—people whom we might never meet and yet with whom we might have long, even intimate, conversations.

If we put these two defining digital technologies, graphics and networking, together, then we get global hypermedia on the World Wide Web—or we get a more poetic vision: novelist William Gibson's cyberspace, a globally networked virtual reality. In either case, digital technology today offers an experience that is more vivid than the phrase *information processing* can convey.

To design a digital artifact is to design an experience

We live in a media-saturated environment, in which many different forms and technologies compete for our attention. The traditional media (television, radio, film, and magazines and newspapers) are far from dead, and new digital forms, from video games to Web pages, must compete with them and with each other. The design of even the most business-like computer applications must take this competition into account. Computer applications can no longer afford to be (if they ever were) simple channels for the delivery of information, as if that were the same thing as delivering milk or cat food. Every application must be an experience.

In fact, interacting with a computer was an experience even before the computer was a medium, even in the era of plugboards, magnetic tapes, and punch cards. Talk to the veterans of the days before computers had interfaces, and they will tell you about the laborious process of inscribing programs on decks of punch cards. In the 1940s, 1950s, and 1960s, to use a computer meant to operate a machine. Yet even batch programming by punch card had its own rhythms and even pleasures. Anyone who really disliked the required precision and repetition presumably went into some other line of work.

Today, we do not operate computers; rather, we interact with them, and successful digital artifacts are designed to be experienced, not simply used. The term *user* is unfortunate (but now unavoidable), as if we were habituated or addicted to the artifact. Good digital designs do not addict; they invite us to participate, to act and react. To design a digital artifact is to choreograph the experience that the user will have. If the design is too restrictive, the choreography too heavy-handed, the experience

To design a digital artifact is to choreograph the experience that the user will have.

may alienate the user. (The whole genre of computer-based training is heavy-handed in this sense.) If the design is ill defined, however, we cannot figure out what genre we are in. A new application can fail precisely because the user does not know what it is for.

Hypertext itself almost failed in this sense because people couldn't grasp what it was for. Ted Nelson, who coined the term, wandered through the computer world for more than twenty years talking to anyone who would listen about his vision for a global hypertext system he called Xanadu. A combination of the McDonald's franchise and an electronic Library of Congress, Xanadu would have linked together much (and eventually all) of the world's texts. In 1984, Nelson wrote that by the year 2020, "there will be hundreds of thousands of file servers—machines storing and dishing out materials. And there will be hundreds of millions of simultaneous users, able to read from billions of stored documents, with trillions of links among them" (Nelson 1984, p. 0/12). For Nelson, the Xanadu system had to be perfect, however—no compromises in architecture or coverage. He was waiting for this perfect system in order to organize and incorporate all of his own ideas and writings. The legend is that the rooms of Nelson's house were filled with slips of notepaper waiting to be fed into Xanadu and "intertwingled." Xanadu was never built, except in ephemeral prototypes, and almost no one else could see why hyperlinked texts were necessary at all. Tim Berners-Lee and then Mark Andreessen finally came up with the right package in the form of the World Wide Web. Here was a media form that people could understand—a combination of electronic text and images that recalled all the uses of graphic design for print and ultimately promised global multimedia. It could be a digital library for scholars and scientists, but it could also be a new kind of shopping mall for consumers. It could entertain surfers with everything from pornography to the virtual Louvre. The Web finally presented hypertext as a convincing digital experience.

Such a digital experience does not simply enhance the delivery of information. The information itself becomes an experience. Even word processing programs and spreadsheets provide experiences. Using a word processor may be frustrating, as it is with Microsoft's animated paperclip (the software agent from hell) that insists on advising you how to write a letter when you are not writing a letter. Nevertheless, it is an experience. Listen to your friends and colleagues complaining about the Microsoft paperclip; it annoys them in a way that they want to share with you, just as they want to share the experience of having their flight cancelled or being caught in a two-hour traffic jam.

In a similar fashion, people like to share their adventures on the Web. William Gibson's often quoted description of cyberspace in *Neuromancer* (2000) really does seem to fit the Web: "a consensual hallucination experienced daily by billions of [human beings]" (51). The Web may still have only millions of participants, but it is an experience of enormous

power. Pragmatists like Jakob Nielsen, who tell us that the Web is about gleaning information as rapidly as possible from transparent pages of words and images, do not seem to understand why this technology is extraordinarily popular. They tell us how bad most Web sites are at conveying information. Yet if the Web is so bad at doing what it is supposed to do, why do millions of people choose to share the "hallucination"? The Web is a multimedia experience in which users are prepared to indulge for five, ten, or twenty hours a week, and the visual design of Web pages is not "window dressing" for the content. The form and content of Web pages are inseparable. Pragmatic explanations of the Web as an information system are not wrong, but they are insufficient. The same pragmatic explanation fails to account for the influence throughout the twentieth century of visual design in posters and magazines and on television. It fails to explain why successful corporations have been willing to pay millions of dollars on branding and design programs for stationery and physical products and why they continue to do so on the Web.

In the past decade, some digital designers have come to speak of their task as "interaction design," understanding an interface or application not as a series of static screens, but rather as a process of give and take between computer and user. Interaction designers must keep in mind a world of if-then scenarios. In a sense, they must think like scriptwriters preparing the dialogue for a film or play, but with a key difference: in a film or play, the dialogue is fixed, while in a digital interface, the possibilities multiply as the user's choices call forth different visual or textual responses from the computer. A digital artifact can be designed to unfold in multiple ways. The best digital art can help us see how to design for multiplicity, because such art adapts itself to the user rather than forcing the user to follow a **Works of digital art are experiments in interaction design.** rigid script. Works of digital art are experiments in interaction design. They can afford to be radical experiments because they do not have to meet the (often contradictory) demands of a client. As pure interfaces, they demonstrate that content and form are inseparable. A work of digital art can isolate and explore with clarity the relationship between itself and the user.

As Nathan Shedroff (2002) puts it, "The emphasis in Interaction Design is on the creation of compelling experiences," and for that reason he also calls his approach "experience design." Shedroff is one of a number of innovators (including Clement Mok, Richard Saul Wurman, David Kelly, Shelley Evanson, and Hugh Dubberley) who are bringing graphic and

Figure 1.10
Workers at SIGGRAPH
2000, playing in the TEXT
RAIN.

visual design together
with information design
in the digital realm
(Winograd 1996; Wurman
and Bradford 1996). Their
goal is a digital experience
that is carefully structured
yet both visually com-
pelling and open to creative interaction with the user. The interaction between designer and
user *through* the technology is what gives the experience its meaning. Experience design is
also contextual, in the sense that designs must both respond to and shape the many contexts
(personal, physical, and cultural) in which they function.

Digital art is an expression of this new design philosophy. When we walk into the
SIGGRAPH Gallery, we expect to have an experience that we would not have in everyday life.
We are prepared to let the artist-designer choreograph our experience. If the design is success-
ful, however, the experience can seem both inevitable and surprising.

To set up SIGGRAPH in the enormous bays in the Morial Convention Center, con-
struction workers with forklifts and scaffolds were needed. As these workers assembled the
Art Gallery, they too began to play with *TEXT RAIN*. They caught the letters on the railings
of their forklifts (Figure 1.10). Instantly and effortlessly, *TEXT RAIN* became part of their
working world. *TEXT RAIN* is not an elite piece of art, but an experience to be appreciated by
both construction workers and Ph.D.s in computer science. It manages to be immediately
accessible to a broad audience.

Digital applications offer an experience like that offered by books, films, and photo-
graphs: a media experience that is also an "immediate" experience. The essence of digital design
is to work on two levels at once—to be both mediated and immediate. Digital applications

cannot deny that they are media forms, depending on highly sophisticated, electronic technology. At the same time, in crafting digital applications, designers must try to make their work easy to grasp and accessible for their users. Digital art, like the work at SIGGRAPH 2000, contributes to digital design by showing us how media forms can also be immediate.

TEXT RAIN, for example, combines forms of print and video to give us a new kind of reading and writing. A poem and a television show at the same time, *TEXT RAIN* is both visible and invisible as a media form. The participants find the interface so easy to use, so natural, that they need no instruction at all. They understand instantly how to project their images on the screen and interact with the falling letters. The space of *TEXT RAIN* is an image of the physical world and at the same time an interface, a space for the manipulation of texts.

Digital art, like other digital applications, often opens a window for us, as we look through the computer screen to see the images or information located "on the other side." But *TEXT RAIN* is also a mirror, reflecting us as we manipulate the letters. It is as if we have passed through the screen and find ourselves inside some malfunctioning word processor that is raining letters down on us. *TEXT RAIN* surprises and pleases us by being simultaneously a mirror and a window. If there is one reason that digital art is important for digital design, it is this: digital art reminds us that every interface is a mirror as well as a window.

Digital design should not try to be invisible

Think of the computer screen as a window, opening up onto a visual world that seems to be behind or beyond it. This is the world of information that the computer offers: texts, graphics, digitized images, and sound. Concentrating on the text or images, the user forgets about the interface (menus, icons, cursor), and the interface becomes transparent. HCI specialists and some designers speak as if that were the only goal of interface design: to fashion a transparent window onto a world of information.

There are times, however, when the user should be looking at the interface, not through it, in order to make it function: to activate icons or to choose menu items, for example. At such moments, the interface is no longer a window, but a mirror, reflecting the user and her relationship to the computer. The interface is saying in effect, "I am a computer application, and you are the user of that application." No interface can be or should be perfectly transparent, because the interface will break at some time, and the user will have to diagnose the problem. Furthermore, even when the interface is working, we should not allow

it to take us in completely. If we only look *through* the interface, we cannot appreciate the ways in which it shapes our experience. We should be able to enjoy the illusion of the interface as it presents us with a digital world. But if we cannot also step back and see the interface as a technical creation, then we are missing half of the experience that new digital media can offer.

If we only look *through* the interface, we cannot appreciate the ways in which it shapes our experience.

The same would be true if we treated any other medium as exclusively transparent. When we watch a film, we can sometimes get so absorbed in the story that we may temporarily forget about everything else, even that we are watching a film at all. The film as an interface has become transparent for us. Sometimes, however, we want to step back and appreciate how the film was made. This awareness enriches the experience of the film, and not only for a small group of film scholars. Many viewers of this popular medium are eager to learn more about how films are made, and they can. If we buy the DVD version of *The Sixth Sense,* for example, the disk includes scenes left out of the final cut, an interview with the director, M. Night Shyamalan, and descriptions of the special effects. These segments ask us to reflect on how the film succeeds in scaring and fooling us. Popular interest in the process of making films, television shows, and music has increased in recent decades, so that we enjoy all of these media forms as mirrors as well as windows. The same is true of the computer, itself now a medium. Every digital design functions as both a window and a mirror.

When we look in a mirror, we see ourselves, and we see the room behind and around us—that is, ourselves in context. Digital interfaces are like mirrors in the sense that they reflect the user in context, including her physical surroundings, her immediate working or home environment, and the larger environment defined by her language and culture. They do this work of reflecting whether or not the designers consciously intend it. Because the user brings all of these contexts to her interaction with any digital interface, the design cannot help but reflect them. The success of an interface, however, depends on the ways in which it can adapt to these contexts. The most compelling interfaces will make the user aware of her contexts and, in the process, redefine the contexts in which she and the interface together operate. This is where digital art can make a special contribution, because digital art is precisely the kind of interface that both reflects and redefines contexts.

Like other digital artists in the past two decades, those at SIGGRAPH 2000 want us to be aware of the contexts in which their individual works in particular and digital technology in general function. For that reason, there are more mirrors than windows among their exhibits. *TEXT RAIN* is a mirror that reflects its users, for as passers-by are caught by the camera, they find themselves projected on the screen in a rain of falling letters. The exhibit we visit in chapter 2, called *Wooden Mirror*, combines mechanical and electronic technology to produce a beautifully textured image of its visitors. In chapter 3, we visit *Nosce te ipsum* ("know yourself"), a digital collage that contains at its center a captured video image of the visitor. Other pieces in the gallery are mirrors in a metaphoric sense, reflecting the layers of media and culture in which we find ourselves situated today. *Magic Book* and the *Fakeshop* Web site remind us of the variety of media forms that surround us in our media-saturated culture. *T-Garden* concentrates on the spatial context in which we as embodied creatures operate, and *Terminal Time* reminds us playfully of the ideological lenses through which we understand history. None of these pieces is content just to reflect us; they all invite us to reimagine and redefine our contexts.

Taken together, all of these pieces from SIGGRAPH 2000 demonstrate the value of digital art for the larger fields of digital design and HCI. Works of digital art have a critical function: they critique the art of design itself. They make us aware of the assumptions that are built into the practices of designers and computer specialists. Because computer designers so often assume that the interface should be a window, digital art insists that the interface can also be a mirror. And in the process, it demonstrates the other great strategy of digital design. Those who understand and master both strategies will be more effective designers.

Chapter 2. Wooden Mirror
THE MYTH OF TRANSPARENCY

The desire for transparency

is a cultural choice.

It is important for designers and
builders of computer applications
to understand the history of transparency,
so that they can understand that they have a choice.

Wooden Mirror

As you approach *Wooden Mirror* in the gallery, you see what appears to be an old-fashioned, octagonal picture frame. Within the frame, there seems at first to be no picture at all, just the even texture of rows of polished wooden tiles, which look like the tiles from the game of Scrabble. But as you come closer, the tiles begin to move. With a pleasant clicking, some tiles come to a different angle and change color. They continue to move in rippling domino patterns as you move. When you stop, the tiles stop too, and you realize that they have formed a coarse image of you. The mechanism is a digital mirror that reflects the person who stands or sits in front of it (figure 2.1).

A concealed video camera captures your image when you step in front of the mirror. The data are digitized and fed into a computer, which sends signals to control tiny relays behind each tile. As the artist, Daniel Rozin, explains, "The non-reflective surfaces of the wood are able to reflect an image because the computer manipulates them to cast back different amounts of light as they tilt toward or away from the light source" (*SIGGRAPH 2000,* p. 68).

We are used to seeing our image captured by video cameras and displayed on monitors, and this mirror should seem low tech in comparison to a conventional video, as its grained tiles click into place to define our reflection. But the blend of digital technology and wooden material is so unusual that it seems less "natural" and at the same time more engaging

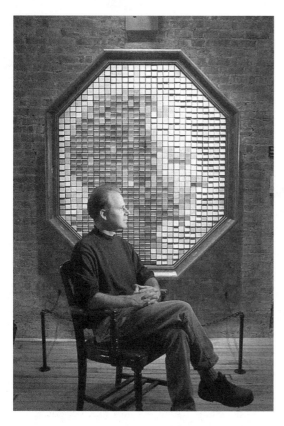

Figure 2.1
Daniel Rozin, Wooden Mirror:
Reflecting a seated figure.

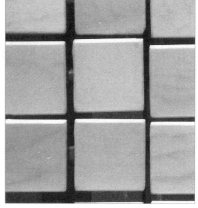

Figure 2.2
Wooden Mirror: *Analog (wooden)*
tiles in a digital design.

than a video display. In using wood to create a digital image, *Wooden Mirror* blurs the line between the analog and the digital (Figure 2.2). It also shows that digital artifacts do not have to disappear into the ether of cyberspace; they do not have to be disembodied and immaterial.

Like *TEXT RAIN, Wooden Mirror* invites us to create our own image; it also invites us to watch others as they create theirs. At any time, there may be one or a few active participants surrounded by a larger audience of onlookers, who then become participants themselves. The exhibit is open to the space of the gallery. We can approach from anywhere within the field of view of the camera, so that the transition from onlooker to participant is easy and spontaneous.

The measured responsiveness of this mirror fascinates us as participants or as observers. It seems like telekinesis that we can move our arm or nod our head, and the tiles slide into place. People experiment playfully to see how their actions will affect the image.

Two women discover that if they stand very still and then blink their eyes, a few of the tiles mirror their blinking.

Looking into a silvered mirror is an experience of looking at and looking through at the same time. A mirror seems to be transparent and to reveal a world parallel to our own, an idea that has always had a sense of menace as well as fascination. How many authors, like Lewis Carroll, have imagined characters stepping through the looking glass? How many have imagined characters stepping out of the mirror to trouble us in this world? And yet the image offered by a mirror is what optics calls "virtual," not "real." The rays of lights only appear to come from beyond the glass. We are really looking at the surface of the mirror, and what we are seeing is a reflection of ourselves and the world around us.

So as its name suggests, *Wooden Mirror* is a paradox. It is a mirror made of the unlikely material of wood. It is opaque, and yet it reflects. It is a digital artifact, and yet it forms its image through a complex and delicate mechanism. *Wooden Mirror* is also a playful reminder that a mirror is a surface and not a window onto a different world. It is a strangely truthful kind of mirror that doesn't deliver on its promise of transparency, in part because the wooden tiles have a pleasing texture that makes us aware of the surface. The piece just manages to fulfill its duty as a mirror. As Rozin says, "The image reflected in the mirror is a very minimal one. It is, I believe, the least amount of information that is required to convey a picture. . . . It is amazing how little information this is for a computer and yet how much character it can have (and what an endeavor it is to create it in the physical world)" (*SIGGRAPH 2000*, 68). *Wooden Mirror* also demands some effort on the part of its viewers: to impress exactly the image they want on the mirror and to find themselves outlined in the wooden tiles.

Wooden Mirror isn't just about the silvered mirror, which is a technology that dates back to Roman times. It is also a comment on digital artifacts and interfaces—a comment on how computer applications reveal information and reflect their users and the process of production. The textured surface of *Wooden Mirror,* which responds so playfully to our movements, helps us to understand the conventional computer screen as both a window and a mirror.

The history of disappearing

Here's a parable about two contemporary interface designers. (We've changed the names and set the story in ancient Greece to protect our royalties.)

Two great painters, named Parrhasius and Zeuxis, entered into a competition to see who could create the most lifelike painting. Zeuxis offered for his entry a painting of grapes on a theater wall that was so successful that birds were deceived and flew down to eat them. Parrhasius offered as his entry the painting of a linen curtain on the same wall. When Zeuxis saw it, he thought it was a real curtain and proudly ordered it lifted so that his painting of grapes could be revealed. When he realized his error, Zeuxis conceded the victory to Parrhasius on the grounds that he (Zeuxis) had fooled some birds, but Parrhasius had deceived Zeuxis himself, a fellow artist.

In the story, Zeuxis is great because he could make his technique disappear—make the viewer unaware that the grapes were really smudges of paint on a wall. His technique becomes transparent, and the viewer sees grapes instead of paint. The fact that the "viewers" are birds suggests that Zeuxis could deceive nature itself. But his rival, Parrhasius, is even better, because his painted curtain becomes transparent even to Zeuxis himself.

It isn't really our story. When the Roman author Pliny the Elder told it in the first century A.D. (in his *Natural Histories,* Book 35, Chapter 65), it expressed the almost universal attitude toward art among the ancient Greeks and Romans. But it is striking that the story could still apply to information designers today. Although such designers today are not (often) creating pictures of grapes—they are making textual and visual information available through their interfaces—they still believe that the medium should disappear. For them, the ideal interface is a transparent window onto a world of data. The user is not supposed to notice the interface any more than the viewers of Zeuxis and Parrhasius noticed the paint on the wall. The user should look through the interface, just as the crows looked through and saw the grapes.

It does not have to be this way, however. Painters do not have to aim for transparency, and neither do digital designers. The desire for transparency is a cultural and historical choice. In the history of Western painting and design, it is true, transparency has been the goal of most artists or designers, but some artists in other periods have had other goals. If those who design contemporary computer applications understand the history of transparency, they will realize that they too have choices in today's media environment.

If designers of computer applications understand the history of transparency, they will realize that they have choices.

The desire for transparency, strong in ancient Greece and Rome, grew even stronger in the centuries after the Renaissance. This desire led to the development of the technique of linear perspective, ascribed to the fifteenth-century painter Brunelleschi, who began a tradition of perspective painting that continued into the nineteenth century. Paintings, like digital applications, offer an experience, and perspective painting offered the same experience as the one now promised by virtual reality—the experience of "being there." As the viewer, you were supposed to be able to reproduce the experience of the artist as he looked on the scene (or the imagined experience as he constructed an imaginary scene).

The word *perspective* comes from the Latin word for "seeing through," and that's what you as a viewer were supposed to do. If you stood at a predetermined place in front of the picture, you could look "through" it to the objects represented. The surface of the picture (the framed canvas or the painted wall) became your window onto a depicted world. In his treatise *On Painting,* the painter and writer Alberti used exactly that metaphor: "On the surface on which I am going to paint, I draw a rectangle of whatever size I want, which I regard as an open window through which the subject to be painted is seen" (Alberti 1972, 55).

For four hundred years, most Western painters were using linear perspective and foreshortening to create the illusion of such a window. Furthermore, when the photographic camera was invented in the nineteenth century, it seemed to create linear perspective automatically, or "naturally." One of the pioneers of photography, the Englishman William Henry Fox Talbot, called the camera "the pencil of nature" and so helped to initiate a century of debate about art and photography. Did the camera render painting obsolete? Was the photographer an artist or simply a technician? The camera did its job so well that painters were compelled to reevaluate their goals, and eventually many abandoned the techniques of perspective painting. Yet photographers and, later, filmmakers and television producers continued to pursue and perfect the techniques of visual illusion and transparency. We still usually regard photographs, movies, and television programs as transparent windows onto a real or imagined world.

Transparency in painting meant creating an image that fools us—makes us think we are looking at the physical world; it meant what computer graphics experts now call photo-realism. The desire for transparency carried over to the other arts and other forms of representation, even to the art of displaying words rather than images. The demand for clarity and simplicity is another version of the desire for transparency, and in this sense, transparency has

also been the goal of typography. For hundreds of years, printed books have been designed so that we as readers look through the pages, not at them.

As readers, we are supposed to focus on the meaning of the words in a book, and the typeface should convey the words to us without our noticing the style of type. Although typefaces since the fifteenth century have varied in all sorts of subtle and beautiful ways, these variations were meant to be appreciated within the guild of typographers themselves, not by us as readers. We were not supposed to notice the harmony of the letterforms of an Old Style typeface such as Bembo (figure 2.3).

That tradition remains powerful today. Unless you are an experienced graphic designer, you probably do not know the name or even the style of the typeface that you see on this page and throughout this book. (It's Adobe Garamond, by the way, which is based on an Old Style typeface.)

The typographers did their work so well that, even in the twentieth century, font designers had difficulty obtaining patents for new fonts because judges and lawyers could not see the changes as significantly new. (To get a patent, you have to show that your invention is a significant change over the "prior art.")

What was true of typography was true of graphic design in general. The early twentieth century witnessed a revolution in visual design that was the counterpart to the revolution in visual art. Just when artists apparently ceased to care whether their paintings looked like things in the world—when Picasso started painting women with two eyes on one side of their head—graphic designers and visual poets started to scatter words and images around on the page in ways that would have scandalized earlier typographers. But in fact, even the modernists—especially modernists of the Bauhaus, de Stijl, and later the International Style—were seeking the same goal of transparency through new means. The hallmarks of their design, asymmetric arrangement and sans serif type, were not meant to obscure the text, but rather to ensure that the design would be immediately readable.

Figure 2.3
Bembo, an Old Style typeface.

Figure 2.4
Jan Tschichold, The New Typography, *1928: Modernist clarity in typographic design.*

The leading figures of this revolution, such as the typographer Jan Tschichold, believed that they were clarifying design by removing the obscure ornamentation that had accrued like rust in the previous decades and centuries (figure 2.4). They sought clarity and transparency above all. In 1928, Tschichold wrote exactly this in his *New Typography:* "The essence of the New Typography is clarity. . . . This utmost clarity is necessary today because of the manifold claims for our attention made by the extraordinary amount of print, which demands the greatest economy of expression." And again: "It is essential to give pure and direct expression to the contents of whatever is printed" (1998, 66–67).

This could be Jakob Nielsen speaking about the Web today. The desire for transparency has also taken hold among HCI and computer graphics specialists, so that the goals of contemporary interface design are ironically the same as the goals of the modernist design of the early twentieth century.

Photorealistic computer graphics

> Reality is 80 million polygons per second.
> —Alvy Ray Smith in Rheingold, *Virtual Reality*

The philosophy of transparency has a history, and computer graphics and interface design continue this history. Photorealistic computer graphics is about making the medium (the computer screen or other video device) disappear. This was certainly a goal of the computer movement from the time of the first graphics programs in the 1960s and 1970s, when Ivan Sutherland, Alvy Ray Smith, James Blinn, Ed Catmull, and many others led the way.

To achieve transparency, these pioneers adopted the principles of projective geometry, just as the Renaissance painters had done. Historians say that when Renaissance painters

perfected the techniques of linear perspective, they were applying mathematical principles to painting. In fact, painters often used their aesthetic judgement to distort the perspective in order to achieve certain effects. In pursuing photorealism in the late twentieth and early twenty-first centuries, computer graphics experts applied rigorous mathematical principles to calculate the exact lines of projection. They have made into algorithms the principles that painters had followed informally and that analog cameras had followed automatically (figure 2.5).

center of projection

Figure 2.5

Perspective projection: Representing 3D figures in a 2D plane with mathematical precision.

 The computer could be programmed to draw the outlines of objects in perfect linear perspective. But in order to achieve photorealism, the objects also had to appear with the proper texture, lighting, and shading. Sophisticated hardware and software were needed for techniques such as texture mapping, (light) ray tracing, and Phong shading (figure 2.6).

 As computer graphics specialists developed (and sometimes gave their names to) these techniques, artists and illustrators began to adopt them. Today there are hundreds, perhaps thousands of photorealistic computer artists, both commercial and amateur. (Some of their work is intriguing. Much of it is the digital refashioning of those earnest illustrations that have graced science-fiction and fantasy magazines since the 1930s, with aliens walking

Figure 2.6

The legendary computer graphic teapot: in wire frame, with texture mapping, and with Phong shading.

through vast canyons on foreign planets and spaceships cruising the realms of surrealistic space.) Even harder than photorealism is what we might call filmic realism: creating animated computer graphics that are indistinguishable from live action films. Hollywood animators and special effects artists, who have been using computer rendering and compositing for decades, apparently move closer to filmic realism with each new FX film. Human actors worry openly that animated actors may one day replace them; animated films from *Toy Story* (1995) to *Final Fantasy* (2001) seem to bring that day closer. Graphics pioneer Alvy Ray Smith once said that "reality" was "80 million polygons per second," meaning that the computer would have to be able to display that many polygons on the screen in real time to achieve fully realistic images. This would be the ultimate victory for the strategy of transparency because it would no longer be possible for the viewer to see the medium (computer graphics animation) at all. She would see what appear to be human beings in what appears to be the physical world. What began in the Renaissance, or with Zeuxis in ancient Greece, would culminate in cyberspace.

The GUI in our visual culture

It isn't only computer graphics artists and animators who inherited the strategy of transparency; interface and computer designers did as well. If computer graphics artists are trying to compete with the Renaissance painters, interface designers are trying to do for the computer what Jan Tschichold and modern graphic designers did for the printed book. They are trying to make their designs simple, clear, transparent—in other words, "usable." It is not surprising that modern graphic design and contemporary interface design would share these goals, because both are about communication with words and images. Both developed along with a new technology. Modern graphic design came after lithography and other extensions of nineteenth-century print technology. Interface design grew out of the efforts of computer scientists to make a graphical computer, which gave us the graphical user interface (GUI).

Who invented the GUI? There are several candidates for the honor: Douglas Engelbart, Alan Kay, and those who worked with Kay in the Learning Research Group at Xerox PARC. No one ever thinks of nominating Alberti or Brunelleschi, but they were the patron saints, if not actually the inventors. The details of the GUI—the particular desktop metaphor, the mouse, overlapping windows, and so on—were the result of effort and inspiration by individuals, most of whom worked in the Silicon Valley in the 1970s and 1980s. But

the GUI became inevitable as soon as computer graphics technology was developed. The reason is that the desire for transparency has been so powerful in our culture for such a long time, and the GUI is the prime expression of that desire in the medium of computer graphics.

Computer interface design itself began with the development of the GUI. Prior to the work of Engelbart and Kay, we could say that computer applications did not have consciously designed interfaces at all. Computers had devices (punch cards, paper tape, teletype) for input and output, but these devices were not designed to provide the user with a consistent experience. The people who created the GUI recognized the power of the computer as a graphics engine and understood that digital technology could be a visual experience.

The rise of computer graphics also corresponded to the growing importance of the visual in our culture. Movies and television were already established as the dominant popular media, and in these popular media, a style of visual realism prevailed. People went to the movies to watch very unlikely stories of romance and adventure played out in a compelling and visually realistic manner. Television drama and to some extent even sitcoms showed real-looking people in real-looking places, even though what happened to these people was unusual and even absurd. Meanwhile, television news brought us what was happening in the world (such as the Vietnam War), and sometimes it brought us these events "live"(broadcast as they happened). The live action of television seemed to reach almost anywhere on earth and, amazingly, even beyond the surface of the planet, as shown by NASA's broadcasts from earth orbit and eventually, in July 1969, from the surface of the moon. Neil Armstrong's "giant leap for mankind" was also a giant triumph of television technology, as the ghostly black-and-white image of an astronaut setting foot on the moon became the crucial validation of the space program's success. Armstrong's leap became reality because it was televised. Was it long after that supermarkets began to put tags on their sale items reading "as advertised on television," as if that validated the product? We still live in the era of televised reality, a point made seriously by the destruction of the World Trade Center (televised live to millions) and satirically by such films as *The Truman Show* (1998) and *EdTV* (1999).

Prior to the invention of the GUI, the computer did not seem to have anything to do with television or our culture's move toward visual realism. It was by inventing the GUI that Engelbart, Kay, and others convinced us that the computer was a medium. In doing so, they weren't just giving us a new tool for word processing and bookkeeping; they were also showing how the computer could play a role in our visual culture. In the 1980s, when the

introduction of the PC and the Macintosh made computers common, we as a culture had to decide once again what computers were for. The PC and the Mac represented the two views. The Mac with its GUI interface presented Xerox PARC's vision that computers could be a new visual as well as verbal medium. The PC with its DOS operating system and ASCII screen insisted that the computer was a symbol manipulator, not a new visual experience. The debate persisted for years. There were those who insisted that the command-line interface was superior to the GUI and claimed they would never touch a mouse. The GUI was for sissies, they would say: real programmers don't point and click. But it soon became obvious that the macho command-liners were defending a cultural definition of the computer that was failing. At first, the GUI was seen simply as a better way to process text, but when color graphics and higher-quality sound were introduced in the late 1980s, the PARC and Apple vision of multimedia triumphed. Microsoft Windows replaced DOS, and soon everyone had a graphical computer.

The computer window

Names matter. When interface designers chose *window* to describe the framed rectangles on the screen that present text or graphical data, they made a choice that had vast cultural significance. As a result we have spent the past twenty years opening, staring at, resizing, minimizing, and closing "windows." The most widely used single piece of software is named for the metaphor that these designers came up with. They could have chosen *frame* instead of *window,* but that choice would have had just the opposite significance from the window metaphor. The reason is that a frame is what surrounds and encloses a window or a picture. The word *frame* reminds us of the interface, while the word *window* helps us to forget the interface and concentrate on the text or data inside. Just as we gaze through a window in the physical world, the GUI's window metaphor suggests that the interface can present data, words or images, as they "really are"—without distorting them. The words and images are "in the machine," just beyond the window and available for our manipulation. The designer's task is to make the interface transparent to the data.

Interface designers were depending on Alberti's powerful cultural metaphor. Painting, photography, film, and television all offered versions of this window, and now the computer was offering its version. And there could indeed be a world beyond the computer screen. Ivan Sutherland, the man who more or less invented computer graphics and did

invent virtual reality, came up with the metaphor of jumping into the computer screen and being immersed by a computational world. John Walker elaborated Sutherland's vision in his article "Through the Looking Glass" when he claimed that the goal should be "to move beyond the current generation of graphics screen and mouse, to transport the user through the screen into the computer" (1990, 44). For Walker, the interior of the computer turns out to be cyberspace, a new world, a virtual reality.

Making the interface disappear

To wizard-of-oz has become a verb. When designers are building a complex new system, they may want to test part of the system before other parts have been completed. Suppose they have designed and implemented the graphics for a virtual reality system, but haven't finished the programming and hardware for tracking the position of the user. They rig up a test to give the user the illusion that the whole system is working. Whenever the user moves forward, a programmer seated at another computer simulates the user's movement with a mouse. They call this *wizard-of-ozzing* it, referring to the scene in *The Wizard of Oz* when Dorothy and her companions accidentally glimpse the phony Wizard at the control panel, calling up smoke and noise to enhance his image. Dorothy and her friends are instructed to "pay no attention to the man behind the curtain." In this case, the programmer is the man behind the curtain, and the hope is that the user, unlike Dorothy, will not notice that the programmer is creating the illusion. Like Dorothy, the user is not supposed to become conscious of the interface.

User interface design belongs to the long tradition of art and illusion that we've been considering. The GUI itself is a systematic illusion that makes it easier for the user to interact with the computer. The user thinks she is opening a folder by clicking on it, but her clicks are really launching a series of computer instructions to fetch binary data from memory

User interface design belongs to a long tradition of art and illusion.

or the disk, convert that data into a graphic form, and display it on the screen as the "contents" of the folder. All the visible objects of the GUI have such operational behaviors, which must be consistent in order to maintain and complete the illusion.

The legendary designer Bruce Tognazzini explained this process to the interface community in his 1993 article, "Principles, Techniques, and Ethics of Stage Magic and the

Application to Human Interface Design." The creators of the GUI at Xerox PARC, he pointed out, referred to the "user illusion." Their desktop metaphor constitutes an illusion, because what is really happening "behind the curtain"—at the level of the software or the hardware—is nothing like what happens to documents and folders on a physical desk. The task of the GUI is to convince the user that the computer *is* her desktop. To convince her, the interface must function like a smoothly running magic trick, where all the elements of the magician's hands, voice, and physical props conspire to distract the viewer from what is really happening. The interface must function smoothly, regularly, and with a seeming predictability. Tognazzini quotes the expert on magic, David Fitzkee, who tells us, "Irregularities destroy naturalness and conviction. When naturalness disappears, and when something unnatural is evident, the spectator's attention immediately becomes vigilant and alert. In the normal course of events, this is disastrous to deception" (355). In the case of the GUI, it isn't a coin or rabbit that disappears; it is the interface itself.

A demonstration of a new application or a new system always has the quality of a performance, indeed a magic performance. Until recently, when Apple or Microsoft rolled out a new system, Steve Jobs or Bill Gates would stand before an excited audience at MacWorld or Comdex. Behind the impresario was a gigantic video screen with his image, which has to remind us of the smoke and mirrors that produced the giant floating head of the Wizard of Oz. Each of these performances was meant to recall the great demonstrations of the past—above all, perhaps, Engelbart's demonstration of NLS, which might be called the first GUI. The effect was magical; the audience saw a display of file management, text editing, and hyperlinking that was unlike anything they had ever seen before. Since Engelbart's performance in 1968, there have been other legendary computing demonstrations. One of the most important was held for a smaller audience, when Steve Jobs and his colleagues from Apple visited Xerox PARC in 1979.

The Macintosh interface

Because the designers of the Xerox Star and the Apple Lisa and Macintosh could not yet enable the user to jump, like Alice's white rabbit, through the screen, they did the next best thing: their windowed interface was a brilliant attempt to achieve transparency. In this case, transparency meant giving the user the opportunity to see her words and images clearly and manipulate them directly and consistently.

Figure 2.7
The Macintosh interface: Multiple windows present different views and different kinds of information.

The Macintosh interface perfected the computer window that Kay and his colleagues at PARC had invented. Multiple windows were the essence of the Macintosh user illusion—more important in the Macintosh than they had been in the PARC interfaces. (This was not true of the knock-off Windows interface created by Microsoft.) The user saw everything through these resizable, movable blocks that contained, managed, and presented texts and images. Windows could be stacked, they could overlap, and each was a view onto a world of information and visual experience (figure 2.7).

Along with the windows came the rest of the desktop metaphor with folders and files, applications with icons that represented the actions of writing and drawing, and the famous trash can for throwing things away. The purpose of the desktop metaphor was not

simply ease of use, but also, and more important, to convince the user what the computer was for. It was for writing reports and memos, figuring budgets, creating layouts and graphic designs—work that goes on in an office or a professional shop. The computer desktop was not a slavish imitation of a physical desktop. There was nothing on a physical desktop that corresponded to the menu bar, and an executive who found a mouse on his desk would call the janitor. Menu bars, tool bars, and pointing, clicking, and dragging with the mouse— these elements all seemed strange to new users. Anyone familiar with a standard line-oriented ASCII display was at first amazed by the GUI—above all, by the ability to work in two dimensions, to be able to move the cursor anywhere within the rows of text arrayed within each window—just as Doug Engelbart's demonstration of NLS had amazed computer profes- sionals more than a decade earlier. After a few minutes or hours of use, however, these fea- tures would move from amazing to predictable. In the late 1980s and early 1990s, when Microsoft adopted these features for its Windows operating system, all computer users became familiar with the metaphor—so familiar, in fact, that we no longer think about these features at all. Soon we expected to interact with a personal computer in this way. The GUI seemed so "natural" and "intuitive" to us that an interface *without* menus or a pointing device now seemed odd. To say that the GUI became naturalized is another way of saying that it became transparent. Today, we look right through the GUI interface, unless some feature does not perform as advertised.

The original Macintosh version of the GUI was an exercise in clarity in the very sense that Tschichold and the modernists had described it half a century earlier: the interface tried to reduce everything to an ideal visual simplicity. The Macintosh computer helped to advance the practice of postmodern graphic design in the 1980s and 1990s, but the interface itself was a triumph of modernist clarity and simplicity. Apple had taken the unusual step of hiring graphic designers, such as Susan Kare, who then

The original Macintosh GUI was an exercise in modernist clarity. It tried to reduce everything to an ideal visual simplicity.

put their skills for reduction and simplification to work in creating character sets (figure 2.8) and icons (figure 2.9) that made good visual sense in the pixel matrices available to them. The Geneva and New York fonts, for example, were pixelated versions of Helvetica and Times Roman, respectively the most important sans serif and serif fonts of twentieth-century print

Figure 2.8

Susan Kare, Geneva and New York fonts, 1984: Modernist clarity in popular digital design.

NEW YORK 12

ABCDEFGHIJKLMNOPQRSTUVWXYZ
abcdefghijklmnopqrstuvwxyz 1234567890

GENEVA 12

ABCDEFGHIJKLMNOPQRSTUVWXYZ
abcdefghijklmnopqrstuvwxyz 1234567890

Figure 2.9

Susan Kare, Macintosh icons, 1984.

ORIGINAL MACINTOSH ICONS (1984)

MacDraw MacWrite MacPaint

design. Kare radically simplified these fonts in order to transfer them from the continuous medium of ink on paper to the discrete medium of the computer screen. Zuzana Licko took this philosophy even further, creating remarkably sophisticated Emigré fonts from a few pixels. Such fonts were also lessons in clarity and restraint (figure 2.10).

From the beginning, the Macintosh interface was conceived according to a design program. Graphic designers had long been accustomed to creating such programs for print applications and corporate identities. The Macintosh visual program extended from the fonts and icons

Figure 2.10

Zuzana Licko, Emigré fonts.

We Read Best What We Read Most (Oakland 8)

We Read Best What We Read Most (Emperor 15)

We Read Best What We Read Most (Modula Bold)

We Read Best What We Read Most (Emigre 14)

We Read Best What We Read Most (Matrix)

to the larger elements of the user illusion, as described in the *Apple Human Interface Guidelines* (1987). And the whole program, not just the font design, was about transparency: "The real point of graphic design, which comprises both pictures and text, is clear communication. In the Apple Desktop Interface, everything the user sees and manipulates on the screen is graphic. . . . Graphics are not merely cosmetic. When they are clear and consistent, they contribute greatly to ease of learning, communication, and understanding. The purpose of visual consistency is to construct a *believable environment* for the users. . . Simple design is good design. Simple designs are easy to learn and to use, and they give the interface a consistent look" (9, 10).

The guidelines were meant to ensure that cutting and pasting would work in the same way in any Macintosh application and on the desktop itself, dialog boxes would look the same and use the same vocabulary, and all windows would be created from a set of predictable shapes and with predictable behaviors. The consistency of the Macintosh interface meant that once the user learned how menus, icons, and dialogs worked, she would be able to apply that knowledge to any application. These interface elements would become natural to her. The interface would disappear from her conscious consideration, leaving her alone with the content of her windows: the documents she was writing or the image she was creating.

The myth of transparency

Digital design is an exercise in mythology, and among the digital mythographers were the creators of the GUI. The windowed interface has defined the way we interact with computers for nearly twenty years. (And what else lasts for twenty years in the computer world, except FORTRAN and C, which seem to be immortal?) The entire World Wide Web was built on computers using some version of the GUI and is now visited by hundreds of millions of users through their windowed screens. The creators of the GUI realized a commanding digital version of the myth of transparency.

In calling transparency a myth, we mean to describe both its strength and its weakness as a design philosophy. A myth allows its believers to construe their experience in a convincing way. Myths are not lies; they are exaggerations or simplifications. In this case, the myth of transparency is a story that artists and designers have told us (and themselves) in order to justify their designs. Because our culture had believed so strongly and for so long in the myth of transparency, interface designers could rely on it to make their designs compelling to users. Many myths are about origins, and the myth of transparency is one of these.

Here's the version that interface designers tell (filmmakers, television producers, painters have told similar stories inflected to fit their media).

The Myth of Transparency Before there were computers—indeed, before there were media of any kind—people were just in the world. People saw things as they really were: there were no pixels, no aliasing, and no need for Web-safe colors. Objects were present to people; the rays of light reflected by objects entered their eyes undistorted by any intervening medium (other than the air itself). Today, a good computer interface gets the user as close to that original experience as possible.

The strength of this myth is that it explains why icons are better than words, why 24-bit color is better than 8-bit. The myth of transparency fosters the user illusion that the interface needs in order to be compelling. It's not untrue, but it does simplify and exaggerate.

The danger comes when designers fail to recognize that the myth is a simplification of a complex reality. This is a danger because the strategy of transparency is never sufficient to dictate the design of a whole interface or artifact. For one thing, as every designer knows, there is a conflict between the simplicity (or transparency) and functionality. As they add functionality, designers often undermine the transparency of their design.

If we set a new Apple computer next to the original little beige Mac, we see a tremendous increase in both power and complexity. As computer hardware has improved, we have capabilities that we did not have in 1984—in graphic display, processing power, memory, and storage. Designers have added more and more features to the interface because of these hardware improvements, but also because of their desire to expand and elaborate the system. Adding new features is the principal strategy for convincing users to buy new versions of a program. That is why Microsoft Word developed from a simple text editor (patterned after Xerox PARC's Bravo) into a suite of interlocking applications that not only format, spell-check, and evaluate our writing, but also annoy us with that dancing paperclip. It is why Web browsers (both Internet Explorer and Netscape) began adding features to write our e-mails and help us stage videoconferences. And it is why the Mac operating system (as well as Windows) continues to grow; the latest versions occupy one or more 600 megabyte CD-ROMs (the first version fit on a 400 kilobyte floppy disk).

With the Mac operating system, as with other software, growing complexity works against transparency. The operating system now contains so many features that it often acts in

ways that even an experienced user cannot predict. Perhaps this "feature creep" is inevitable even with the best designs. If it is, then transparency is an ideal that can never be achieved. In an effort to make the system more powerful, designers are inevitably caught in this trade-off.

As designs grow old and familiar, designers get restless. For interface designers, the possibilities of the GUI seem to be played out. It is a magic trick that is no longer a challenge to perform. Designers want to stay ahead of their audience, so it isn't surprising that designers have tired of the GUI, although their users have not. It's a familiar story in the history of design. In 1951, the head of art direction for CBS, William Golden, designed the famous logo, the eye in the clouds. When he told CBS president Frank Stanton the following year that it was probably time to change the logo, Stanton wisely demurred. He knew that although the designer was ready to move on, the viewers were just getting comfortable with the logo, which lasted decades in its original form and still inspires today's design (Meggs 1998, 364).

Much of the digital design community and certainly HCI specialists seem convinced that at least the GUI, and probably the whole desktop computer, should be replaced. Although the desktop computer with its mouse and overlapping windows has become natural to hundreds of millions of general users, many specialists assume that 3D graphics would provide an even more natural interaction.

Virtual reality and the myth of the natural interface

Transparency goes by other names. In the history of writing and rhetoric, transparency was explained by the terms *simplicity* and *clarity*. In the history of painting, the ideal for many painters was to be "true to nature." In a famous example, the British landscape painter Constable called his *Wivenhoe Park* a transcript from nature (E. Gombrich, 1961), and like painters two hundred years ago, interface designers today want to be true to nature. In their desire to replace the desktop computer and the GUI, they appeal to another myth.

The Myth of the Natural Interface Before there were computers—indeed, before there were any technologies—people were just in the world. They experienced the natural world in three dimensions, and they moved around it with six degrees of freedom. They could touch and manipulate things directly; there were no keyboards and no mice. A good digital interface gets us as close as possible to that natural state, allowing us to interact by movement and direct manipulation.

This myth, which also simplifies and exaggerates, lies behind the work to replace the GUI.

The most conservative approach is to replace the flat look of the GUI with a three-dimensional representation on the computer screen. In place of the two-dimensional folders (already shaded to give a hint of a third dimension), we would see files and folders themselves arranged in three-dimensional perspective, and we would navigate through this projected space. In the movie *Jurassic Park* (1993), the young girl and her brother are trapped in the island's command center. The vicious velociraptors are about to burst in and devour them unless the high-tech, computer-controlled doors can be sealed in time. The girl, a computer geek, manages to navigate the computer system and close the doors, because she can make sense of a 3D interface to the UNIX operating system. The truth, however, is that if she really had to cope with such an interface, the velociraptors would probably be dining before she managed to find the program file.

The more sweeping proposals are to eliminate the need for the user to sit in front of a screen at all. Instead, the user would pass through the windowed screen of the GUI by putting on a VR headset and immersing herself in a world of visualized data. As we have noted, Ivan Sutherland envisioned such an interface when he invented virtual reality in the 1960s and 1970s. As Howard Rheingold wrote in *Virtual Reality*, "Sutherland opened a window, and pointed to the day when people would be able to go through that window and enter the abstract territory that computer simulations could create" (1991, 93). Sutherland was working at about the same time as Alan Kay (at one time a student of Sutherland), but the GUI was ready for the general user long before VR moved out of the research lab. All through the 1980s, as the GUI was conquering the command-line interface, researchers continued to work on VR, and Jaron Lanier, the dreadlocked guru of VR, began claiming that it would replace symbolic communication. He was really imagining that VR would become the ultimate transparent interface. There would be no screen between the user and the information and no way for the user to step back and contemplate the screen at a distance, because she would be wearing the screens as eyepieces that completely covered her field of view. The user would occupy the same space as the data itself. Instead of using a keyboard and mouse, she would grasp and explore data with her hand (wearing a special glove fitted with sensors). Virtual reality as a transparent interface to all human data systems is, after all, the original vision of cyberspace that William Gibson suggested in *Neuromancer.*

VR interfaces are supposed to be natural because they create a visual world in three dimensions, like the physical world we inhabit. Yet the natural interface is a myth, a story that interface designers tell (us and themselves) in order to justify their designs. It is a compelling story because it has roots deep in the history of our culture. We can easily believe that seeing a picture is more basic, more direct, more "natural" than reading words. Even the cultural relativist John Berger wrote in his landmark *Ways of Seeing,* "Seeing comes before words. The child looks and recognizes before it can speak. But there is also another sense in which seeing comes before words. Seeing establishes our place in the surrounding world; we explain that world with words, but words can never undo the fact that we are surrounded by it" (1972, 7). If seeing is more natural and direct than reading, then any visual interface, even the GUI, is more natural and direct than an ASCII interface. By the same logic, the GUI is less natural than an immersive 3D interface, which relies even less on words or other arbitrary symbols.

However, what is considered "natural" can change. Why should it seem natural to put on a headset and navigate in the virtual world? Why is this any more natural than typing on a computer keyboard, or reading a book, or writing on a roll of papyrus (as the ancient Egyptians, Greeks, and Romans did)? For some, the term *natural* is simply a way of indicating that the interface is easy for a beginner to learn or efficient for an experienced user. But even by this definition, the idea of the natural is not constant, because what is efficient or easy in an interface depends on what the interface is for. Some sort of virtual environment is almost certainly more efficient than a GUI in allowing the user to practice visual and motor skills, for example, for flight simulation. But if the task is to navigate through a collection of reports, memos, and spreadsheets, then the GUI may still be easier and more efficient.

Furthermore, 3D interfaces are not radical departures from the GUI. Like the desktop GUI, they are still based on the myth of transparency; they are attempts to make the interface disappear. They simply go further in the direction established thirty years ago by the designers of the GUI. They try to do with pixels what Brunelleschi tried to achieve almost six hundred years ago with paint. The pursuit of transparency is endless, because transparency is redefined with each new technology. The Renaissance painters pursued transparency by applying the technique of linear perspective. The desktop GUI attempted to achieve transparency on screen-based computers, and VR technology now pursues transparency by offering the illusion of three dimensions. These are all versions of the same myth: that a technology can disappear completely and put the viewer or user in touch with reality.

The reason that designers must understand the myth (and the history) of transparency is that the strategy of transparency can be misapplied. As designers, we want the interface to disappear for the user for part of the time, but not completely and not irrevocably. At some subliminal level, the user must be aware of the interface at all times. She must know that she is using a computer and not actually writing on a piece of paper on the desktop. In VR, she must know that she is looking at a virtual world, or she is likely to run into a wall in the physical world. There is always a tension between the two worlds: the world depicted by any digital application and the physical world in which the user must function. (Even the characters in the movie *The Matrix* eventually had to return to the dystopic physical world in which their bodies lived.)

Finally, even if it could be achieved, perfect transparency would be a dangerous mistake. Think of the window metaphor. When a window pane is perfectly transparent, the glass perfectly clear, there is a danger that a bird will fly into it or a person will try to put his hand through it. In the story of the painter Zeuxis, no one, of course, was concerned about the crows who presumably broke their beaks against the wall while trying to get the grapes. But we do know of instances where humans can be endangered by interfaces meant to be transparent.

The dangers of transparency

It's 4:00 A.M. on March 28, 1979. Late night or early morning are the most likely times for natural deaths and serious industrial accidents, perhaps because human operators are at the ebb in their circadian rhythms. (Think about that the next time your pilot is making the complicated preparations for landing your plane in Paris at what is for him 3:00 A.M.) The Bhopal chemical spill in India happened around midnight. At Three Mile Island, it was 4:00 A.M. when the disaster began.

As is usually the case in advanced technical systems, a cascade of failures contributed to the infamous near-meltdown of the Three Mile Island reactor near Harrisburg, Pennsylvania. Emergency feedwater valves had been closed days before for a repair and had never been reopened. The coolant system failed because an unknown operator had destroyed the valve control system by misconnecting a hose. The heat built up. At one crucial point, moreover, operators were supposed to ensure that the cooling system continued to carry away the excess heat. They were watching an indicator that told them that the water level in the coolant system was rising (when in fact it was falling), so they stopped adding water

(Casamayou 1993, 103; Johnson 1999). The problem was that the operators did not question their interface. They treated the valve indicator as if it were a transparent window on the level of water inside the reactor. The operators should have been prepared for that possibility; they should have looked *at* the indicator rather than *through* it. Under the pressure of an emergency, however, they made the assumption of transparency.

At Three Mile Island, the interface consisted largely of analog dials and indicators. But transparency can be the wrong design strategy for any kind of interface, analog or digital, if it lulls the user into thinking that the system is foolproof—if the operator fails to remember that the system may fail precisely in a way that masks its own failure.

Consider our sleepy airline pilot. Ordinarily, he wants to look through the instruments on the control panel (which, by the way, is now likely to be a "glass cockpit," in which the readings are delivered by a computer interface). But when something appears to be wrong with, say, an engine, the pilot always asks himself whether the problem lies in the engine itself or in the instrumentation. Perhaps the engine is fine and the interface is faulty. Pilots need to remember what the operators at Three Mile Island forgot in a moment of high stress: that the instrument is an interface and is never completely transparent. In this case, it may now be called a glass cockpit, but in fact the glass may be a mirror, reflecting what the user is inclined to believe, rather than a transparent window.

It does not have to be a matter of life and death, of course. Failures in transparency occur regularly in desktop computer interfaces. It happens to all of us, even the most experienced users, in part because we do not think to question what the interface is telling us and in part because the interface confuses us with its transparency. For example, in the Windows operating system, users make frequent errors because the interface (by default) hides the three-character extensions on file names. We assume that a file has a certain extension (for example, .htm). We want to open the file in our Web editing application, so we call up the application's dialog box and point it to the folder where we know the file is located. But the file does not appear in the list of files available to be opened. The reason is that the dialog box is "helpfully" filtering out files that do not end with the .htm extension. Because our file doesn't end with that extension, we don't see it. And when we look back at the folder on the desktop, the extensions aren't listed, so it doesn't occur to us that the file doesn't have the proper extension. We can't figure out why the program can't see the file. In the name of transparency, the system puts a cloak of invisibility over the file's full name.

This is the danger of transparency: that the interface will mask the operation of the system exactly when the user needs to see and understand what the system is doing. When something unexpected happens, the user should be able to look at the interface. This is the notorious problem with software agents.

The danger of transparency is that the interface will mask the operation of the system exactly when the user needs to see and understand what the system is doing.

Deirdre Smith-Jones is a graphic designer with an interest in cultural studies. When she visits amazon.com from her home computer, she gets a message on the start-up screen: "Hello, Deirdre Smith-Jones. We have recommendations for you." The recommendations include Marita Sturken and Lisa Cartwright's *Practices of Looking* and Lev Manovich's *The Language of New Media,* which make good sense given Deirdre's interests. But a year ago, Deirdre bought her nephew *Dave Madden's All-Star Baseball 2000,* so now she continues to get offers for new Nintendo games. She bought her mother (who is notoriously hard to shop for) a Martha Stewart book for Christmas, and now she is offered every paean to stylish living published by the Martha Stewart machine. The amazon.com software agent can't easily distinguish between the kinds of books that Deirdre buys regularly for herself and those she buys for others on an occasional basis.

Software agents, especially those on the World Wide Web, try to be transparent and present the user only with results. But these programs are never really smart or subtle: they all make mistakes. And when it fails, a software agent is no longer transparent, no longer the silent butler that it is supposed to be.

Another strategy

The computer window is such an effective design because it can rely on the assumption of transparency. It is important for digital designers to understand this because designers work within and through such cultural assumptions. Like clever magicians, they offer the audience an illusion that it is already prepared to believe. In this case, hundreds of years of painting, printing, and photography have prepared us to look through the new windows that the computer offers. These traditions have inclined us to accept the illusion of virtual reality and other 3D interfaces as well. The task of the designer is to encourage users to follow their inclination to look through the interface.

Designers must also bear in mind that the strategy of transparency, although popular, is not the only one available to them. *Wooden Mirror* in fact uses another strategy, which is the counterpart to transparency: the strategy of getting the user to look *at* the interface or object of design rather than *through* it. *Wooden Mirror* is not transparent; it is an opaque, richly textured surface that nevertheless manages to show the viewer to herself. This is the most important lesson, perhaps, that digital art has to offer for digital design: an interface can be not only a window but also a mirror, reflecting its user.

Chapter 3. Nosce Te Ipsum

SEEING YOURSELF IN
THE DIGITAL MIRROR

Digital artists suggest not that we look through the experience to a world beyond, but rather that we look right at the surface.

Nosce Te Ipsum

If we walk a few steps from *Wooden Mirror,* we encounter another piece that is ultimately a mirror. On a large scrim hanging from the ceiling, we see projected a contour drawing of an androgynous human figure (figure 3.1). The artist, Tiffany Holmes, describes our experience: "As you move closer to the image, you see a line of words across a floor dotted with circular targets. As you walk forward, following the words, you trip a pressure sensor that triggers a change in the animation. Suddenly, layers pull back and reveal that beneath the drawn body lies an

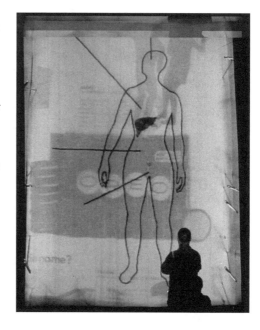

Figure 3.1
Tiffany Holmes, Nosce Te Ipsum: *The first image.*

Figure 3.2

Tiffany Holmes, Nosce Te Ipsum: *Collage technique in digital art.*

interior composed of flesh, letters, words, and marks. Stepping on each target triggers another sensor and a continued shift in the animation as the body folds back on itself, revealing layers of images that give way to further images. When you step on the final sensor, your face, captured in real time with a video camera, appears beneath the embedded layers" (*SIGGRAPH 2000*, 47).

The layered images are more complicated than the single textured image offered by *Wooden Mirror,* and more complicated than the combinations of letters and video images of *TEXT RAIN* (figure 3.2). But like both of these other pieces, *Nosce Te Ipsum* turns out to be a mirror, because it reveals its viewer behind layers of self-dissecting images. *Nosce Te Ipsum* is a digital collage, or "decollage," as layer after layer peels off as we move toward the scrim (figure 3.3).

The phrase *nosce te ipsum* (know yourself) suggests that the user will learn something about herself as she walks forward and is revealed. As she walks, she reflects on her relationship to the digital application. Like other pieces in the SIGGRAPH Gallery, we can understand *Nosce* as a lesson in digital design and a comment on how digital applications affect us as viewers or users. Like the other pieces, *Nosce* is all interface: it does not accomplish the work of information processing as a productivity application (word processor, spreadsheet, or database) does. The viewer, however, does have a task—one of pure discovery. As Holmes explains, "In order to reveal the final image, you must participate in the dissective process. . . . Your steps, timed as you choose, alter the projected body, penetrating the palimpsests of imagery that pull back, one after another, to reveal your face within the larger work" (*SIGGRAPH 2000*, 47).

As we interact with *Nosce,* we make (or unmake) a picture of ourselves. In one sense, *Nosce* is a direct interface, because we make the picture simply by walking along the

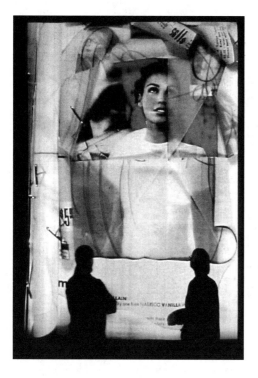

Figure 3.3
Tiffany Holmes, Nosce Te Ipsum: *The layers peel back.*

prescribed path. But *Nosce* is not a transparent window. We do not look through this piece to an imagined world, and we never forget that we are interacting with a digital interface. *Nosce* shows us how a user interface can reflect us as we use it. It calls attention to what we are doing; it makes us stop and think about our relationship to the computer. Even when we are performing the mundane tasks of information processing, we always bring a part of ourselves to the digital applications with which we interact. Digital applications are never fully transparent; they always reflect the user.

Reflectivity: The counterpart to transparency

We break off our tour of the SIGGRAPH Art Gallery for a moment in order to visit an older and even more famous exhibit, the National Gallery in London. We have come specifically to see *The Ambassadors* (1533) by Hans Holbein the Younger. It is a highly realistic scene of two men in Renaissance dress, along with various scientific and musical instruments, but on the floor between them, there is a disturbingly unrealistic and unintelligible shape: an irregular, bone-colored disk (figure 3.4). What can it be? We think it might be useful to get another angle on this part of the picture. (The guard is helpful; he has been helping people find the proper angle, presumably, ever since he started working in the museum.) If viewed from an extreme angle to the right of the painting, in a radical perspective called "anamorphic," the blob turns out to be a skull, a reminder of mortality. The anamorphic skull forces us both literally and metaphorically to look at the painting in a different way. We

have to stand at a different place, and we have to think about the whole picture differently because of the skull.

The skull challenges the illusion of transparency, so that the painting is no longer just a window onto the world. We can't look through the canvas; instead, we have to take an active role in constructing the meaning of the painting. Our experience of viewing the painting is enhanced, but at the same time we are made conscious of our role as a viewer.

From the Renaissance to the end of the nineteenth century, many paintings offered an alternative to the illusion of transparency: humorous paintings in which, for example, a

Figure 3.4
Holbein the Younger, The Ambassadors, *1533. Reprinted with the permission of the National Gallery.*

human face is constructed out of fruit and vegetables; depictions of hell, where the view is deliberately unrealistic; and so on. There are anamorphic drawings and paintings that present a distorted or impossible point of view. There are many paintings in which mirrors are included in the scene, sometimes reflecting the artist and suggesting where the viewer himself might become part of the image (Alpers 1983). Such techniques not only disrupt our ability to look comfortably through the canvas to the world depicted; they also make us think about the process—how a painting functions to represent a world and how we as viewers become part of that process.

In twentieth-century art and design, the alternatives to transparency grew more numerous and influential. It is true that modern designers such as Tschichold wanted to create clean, transparent designs, but that was only one aspect of modernism. Alongside the desire for clarity, there was the desire to create a complex and striking image, to awaken us as viewers from the complacency of looking through the painting or design. This other desire led artists to the technique of collage, which originally meant pasting one media form onto another—for example, pasting newsprint onto the canvas of a picture. The term expanded to include a variety of techniques for layering images produced by different media: paint, print, photography. Although collage has been called the defining technique of modernism, it does not belong to the cool, clear modernism of Tschichold and other graphic designers. It belongs

instead to the improvised modernism of the futurists, dadaists, and lettrists. Because these modernists wanted to make us think about the surface of the painting and the process of creation, their designs were eclectic and multiple. Their work carried over into the 1960s and later, as modernism gave way to various versions of postmodernism, which delighted in the eclectic and in pastiche.

Figure 3.5
Wolfgang Weingart, exhibition poster, 1977: An influential example of postmodern design.

Postmodern designers and artists insisted that the viewer should become part of the process itself. They created disrupted and fragmented images that required us to work to understand them, such as the illustrations of the pioneering Wolfgang Weingart in the 1970s (figure 3.5). There are great cultural and artistic distances between *The Ambassadors* and Weingart, but they share something important: an emphasis on process and an awareness of the act of making.

When transparency and clarity were the dominant goals of our culture's artists and designers, there were always those who questioned this strategy. *Nosce* is part of that tradition of questioning. Its collaged interface is in no way transparent; instead, it promotes itself as an experience in its own right, not a representation or model of something unattainable. The strategy of transparency remains popular today—on TV news programs, for example, and in television and film drama—but its counterpart is also increasingly popular in our media-saturated environment.

When transparency and clarity were our chief cultural goals, there were also artists and designers who questioned this strategy.

Multiplicity in contemporary culture

You're watching a music video on television. (You turned it on as visual wallpaper, but then it caught your attention.) You see a series of rapidly edited images, one disconnected moment after another, with each image lasting five or ten seconds at most. The singer is walking down the road; now she's on the beach. Now she's wearing a dress, now a tuxedo, now a bikini. Is this a video representation of schizophrenia? It is MTV, and it has been among the most popular television channels for almost two decades.

You walk into a bar. Four large television sets are mounted on the walls, so wherever you sit, you can see one or two. Each set is showing a different football game. (The volume is turned down on all the sets, so you can listen to the bar's own sound system as background music.) At the bar itself are small video units offering a networked sports trivia game in which you can compete against not only the other players at the bar, but patrons of other bars on the network.

You go to a rock concert, which is part of the tour of a famous group. When you find your seat in an arena about the size of Yankee Stadium, you gaze down on the stage seemingly a football field length away and look for the musicians, who at this distance are the size of tiny toy figures. Behind the musicians are giant video screens and huge speakers the size of small cars. The show itself is a barrage of sound and light, a multimedia experience in which the actual musicians are only the smallest part of the action. Projections on the giant video screens alternate between live video of the musicians dancing around the stage and prerecorded video appropriate to the concert's theme.

What do these experiences have in common? They are all examples of our contemporary media culture. Many people today, indeed the vast majority in our urban society, choose to surround themselves with complex media forms. They enjoy the multiplicity and prefer not to concentrate on any one medium or representation for very long. Even if they are watching a single media form (say, MTV on television), that form itself is fragmented and multiple. When we surround ourselves with multimedia in this way, the various media forms *constitute* the experience for us. This is a contemporary alternative to transparency: it is the mirror rather than the window—the strategy of reflection, multiplicity, self-awareness in action.

The striking fact is that this strategy is so popular today. The work of painters like Holbein and Vermeer appealed to a relatively small middle and upper class of collectors in the seventeenth century. In the early twentieth century, the futurists, such as Marinetti, and the dadaists, such as Tristan Tzara, performed their multimedia events in tiny coffee houses. They were denounced by mainstream art connoisseurs and were utterly unknown to people who flocked to silent movies and other popular entertainments. Today, Madonna performs her light and sound shows for sold-out crowds of a hundred thousand, who riot if she cancels.

Contemporary design in all its forms must take into account this aspect of our culture. Designers should respond to and appreciate the desire for multiplicity, for making the medium itself an experience to be savored. And, of course, contemporary visual design does respond. Rave design, for example, is a whole aesthetic built around the multiplicity and multimediacy of the mass concert or rave event. Breaking the illusion of transparency is not an esoteric or elite practice. It's what MTV producers, rap singers, and technorock groups are also doing. MTV producers join digital artists in suggesting not that we forget the medium, but rather that we enjoy the medium or process as an experience—not that we look through the experience to a world beyond, but rather that we look right at the surface.

Contemporary culture is receptive to transparency (the window) and also to an alternative, self-reflective style (the mirror). This latter style, which was truly avant-garde in the early twentieth century, has become the aesthetic of rock concerts in the early twenty-first century. So digital graphic designers and the growing world of digital entertainment need to master both styles. Digital interface design needs to master both styles as well.

Contemporary culture is receptive not only to transparency (the window), but also to an alternative, self-reflective style (the mirror). Digital designers and the growing world of digital entertainment need both styles.

Interface design

What we have been describing is a second strategy, a counterpart to the strategy of simple transparency. We can compare this second strategy with the first by listing their respective characteristics:

	Strategy of Transparency	**Strategy of Reflectivity**
Goal	information delivery	compelling experience
Metaphor	interface as window	interface as mirror
Response by user	look through interface	look at interface

These two strategies form a continuum: no digital design can achieve pure transparency or pure reflectivity. Each design is a combination of these two strategies—perhaps with more elements of one or the other. We might be tempted to think that transparency is for "serious" digital applications, such as productivity software, while reflectivity belongs exclusively to art and entertainment. But it is not that simple.

It is true, however, that digital art emphasizes reflectivity. The art of SIGGRAPH 2000 calls into question the assumption that the strategy of transparency can be all-inclusive and self-sufficient. One function of art in the past century has been to challenge such assumptions. The task of the SIGGRAPH Art Gallery is to place itself in the middle of a premier conference on digital technology and ask questions about how digital technology works with us and for us. *Wooden Mirror, Nosce Te Ipsum,* and *TEXT RAIN* playfully question our role as the user, the subject, of a digital interface. These pieces are not simply "art"; they are

also "demos," which we expect to find in a computer conference. They demonstrate compelling possibilities for our interaction with digital applications. They demonstrate how the interface can be made visible to us as a vital part of our experience.

The importance of oscillation (between design strategies)

Designers of digital artifacts—in fact, designers of any media form in our digital era—must mix strategies and create an interface that is both transparent and reflective. This mixing of strategies means that the designers must examine their designs in two ways: from the outside and from the inside. They must look at each design as if they were users, and they must also be able to look at each design critically, from the outside.

When Bruce Tognazzini compared interface designers to magicians, he suggested that designers, like magicians, must live in two worlds: "Magicians live in both the world of their mechanical tricks and the illusory world they are creating for their spectators, but they 'believe' in the spectator's world" (1993, 359). Magicians always deal in two realities. Digital artists and designers too must believe in their illusions—but only up to a point. And the same is true for their audience. In a magic trick, the magician never wants the audience to see the interface, to guess how the trick works. But designers *do* want their users to be able to get behind the illusion at certain times.

Good designs oscillate between hiding and revealing themselves. *Nosce Te Ipsum* oscillates as it unfolds itself before the user and as the elements of the collage peel back to reveal the user to herself. The rhythm of oscillation comes from the interaction of the user with the system and is determined by the pace of the user's walk.

Interfaces should oscillate in a controlled way between states of transparency and reflectivity. The essence of the GUI interface, for example, is controlled oscillation. Alan Kay understood this when he invented overlapping windows, the key element in the GUI. One window in isolation is meant to be transparent, to show the user the data that it contains. Kay and his colleagues came up with the idea that multiple windows on the screen can be stacked or overlapped. At any time, the user can call any window forward and make it the focus of the interaction, and that action of calling the window forward (by a click of the mouse) requires that the user acknowledge the interface, at

Interfaces should oscillate in a controlled way between transparency and reflectivity. The essence of the GUI is controlled oscillation.

least momentarily. For a moment, she must look at the interface, at the stack of windows, and select one, and in that moment the window is no longer completely transparent. It is not only a view of the data, but also a tool to help the user organize her information.

The Macintosh designers inherited overlapping windows (and much more) from Kay and his colleagues at Xerox PARC. In the previous chapter, we noted that the Mac interface strives for transparency, but that is only half the story of this remarkable design. The success of the Mac interface stems from the fact that it does not fully accept its own transparency. But Microsoft Windows, which copies the GUI of the Macintosh, doesn't provide a graceful oscillation. Windows shows the folly of accepting the simple definition of interface design as transparency.

Microsoft Window (sic)

The real problem with Windows is that it was designed by people who didn't love what they were doing. Unlike Alan Kay and his people at Xerox PARC and unlike the Macintosh designers, the Windows designers were following a pattern without fully understanding what it meant. There's no magic in this interface. All the mythology has built up around Alan Kay and the people at Xerox PARC, Steve Jobs, Bill Atkinson, and the makers of the Macintosh. No one ever talks about the makers of Windows. (They have become transparent.)

What's wrong with Windows? It is a remake of the Star and Macintosh interfaces, and it functions adequately. As a result of brilliant marketing and business strategy by Gates and company, it has established itself as the platform for most of the personal computer development of the past decade. But it is precisely because of its dominance that the interface has never had to be as good as the Macintosh. Windows could rely on its market share to perpetuate its market share, because applications developers continue to develop for the most popular operating system. The newest software is always available for Windows.

Yet there are unmistakable, egregious flaws in the interface, and these flaws can be ascribed to an unquestioning pursuit of the transparent. Unlike the designers of the Macintosh, the designers of Windows (or perhaps their managers) lacked the subtlety to understand how to control the rhythms of the desktop metaphor, how and when the interface should oscillate between transparency and its opposite. They always thought they were striving for transparency, which they equated with consistency. They didn't realize when to be

inconsistent. It will come as a surprise to many bewildered first-time users, but in fact Windows is too consistent. The user crashes into the clear window that the system tries to be, and the result is confusion and mystification. Here are three examples.

Multiple programs The multiple launch feature combines with the window-minimizing feature to create a double-whammy for beginning and even some intermediate users. When minimized, the window shrinks to an icon in the taskbar. Often a beginning user will launch Word or another application, type in a paragraph of text, and then hit the Minimize button by accident or because she wants to see something on the desktop. Suddenly her document has disappeared. So she finds the Word icon and launches again. To her dismay, the document she was working on doesn't return (she doesn't understand that the document is pinned to another version of the program). So she types the paragraph again and minimizes again. Beginning users may soon have three, four, or five invocations of the same program in their taskbar, each with the same paragraph (figure 3.6).

This behavior on the part of Windows is logical and consistent, but it is almost *never* what the user wants to do. She doesn't think of the program as separate from her document; she thinks of the two united.

Figure 3.6
Windows taskbar: A failure of transparent design.

Hiding the extensions The Windows interface was built on the DOS operating system, where files had eight-character names followed by dot and a three-character extension (.doc, .txt, .htm, and so on). Those three-character extensions still linger in the Windows system; however, following the principle of transparency, the designers decided to make them invisible. In the default mode, the user sees the file names without the extensions. The problem is that two files in the same folder may now appear to have the same name because their different extensions are not visible. Also, the dialog box that opens files shows only files with the "appropriate" extension. As a result, even an experienced user can have trouble finding the file she wants to open (figure 3.7).

The developers presumably reasoned thus: "The extensions are primarily used to identify the program to which a file belongs. Since the files automatically open their programs, why bother to clutter the screen with the extensions?" The answer is that the operating system is not smart enough to anticipate when the users may need to see the extensions. It should always provide them.

Figure 3.7
Windows file dialogue: It is impossible to distinguish between files with the same name but different extensions.

The menus The designers decided that menus should be attached to windows. It was a logical decision—except that applications often have commands that apply to multiple windows or to all the information in the dataspace regardless of whether there are windows open or not. The consistency of requiring that menus belong to windows leads to inconsistencies: some commands must be attached to a window even when they do not apply to the data in that window, and the whole desktop itself has no menu bar. The user has to look elsewhere and switch her mode of thinking when she reaches the desktop itself and wants to issue a system command. There is a different interface—an elaborate, nested pop-up menu called the *taskbar*.

Despite the inconsistency, users would no doubt have found it easier to have a menu bar on the desktop as well. These are apparently small problems, except that user interface design (like all other visual design) is the sum of a series of small decisions. Furthermore, these and other decisions in Windows are not isolated flaws; they form a pattern. The operating system interface is called Windows, but it should be called Window, because the system does not encourage or help the user to maintain multiple windows. Some applications maximize a single window automatically and block the user's view of the desk. Many users employ key commands to switch from one application to another rather than changing focus by clicking on another window. In every way, it is harder to get an overview of all the applications and resources than it is with the Macintosh interface.

The designers of the Windows wanted a single transparent window onto the world of data; they had no sense of the multiplicity of services and applications that the personal computer supports. Their problem was a slavish consistency rather than understanding when to break a rule.

The designers obviously believed that simplicity and a dogged consistency would promote a sense of transparency. However, the reverse happens: the user often has to spend more time thinking about the interface, when she wants to be thinking about the data, because the interface often hides information that the designers believed the user wouldn't need. Such decisions require extreme finesse. It is very hard to know what details to hide and which to display. To know requires user testing, of course, but also intuition. The designers had too little of either, it seems, or they would never have made the default to hide the three-character extensions to file names. They would never have created the maximized window that sticks tenaciously to the whole screen and refuses to let the user drag it.

Seeing the interface

When, as a designer, do you want your user to be aware of the interface? There are many such moments. For example . . .

- When the user wants to modify the parameters or turn off the automatic features. In the Windows operating system and in Microsoft applications, it can be exceedingly difficult to turn off the automatic features. In trying to be transparent to the task, the program buries such parameters inside layers of interface.

- When the user wants to know where a program is saving temporary files or making archives—for example, where the mail program saves its attachment files.

- When the user wants to know where all the support files are located when she installs a program. For a typical application, there may be fifty or a hundred support files.

- When the user wants to know what is happening when she downloads an application from the Web. The file may be unzipped; it may add a variety of files to her disk and then insert itself (as a plug-in) into her browser.

In general, the user wants (and needs) to be aware of the interface whenever something goes wrong because bugs and failures in a system break the illusion of transparency.

True user-centered design: The interface as a mirror

We now have another perspective on the struggle between Designers such as David Siegel and Structuralists such as Jakob Nielsen, which we described in the Introduction. (If you skipped the Introduction, you can go back to it.) The war of the Structuralists and the Designers is about transparency and reflectivity. Whereas the Designers want their designs to be reflective as well as transparent, the Structuralists believe that transparency is the ultimate goal of all good design.

The study of HCI and usability almost always assumes that transparency should be the goal of all digital artifacts. Nielsen (2000) clearly makes this assumption, for example, in his book on Web design. For Nielsen, a Web site should always be a pipe that delivers information effortlessly to the user, yet such an idealized information Web site would in fact be ineffective. Idealized information sites do not really take into account the audience's contexts and needs.

They turn their audience into consuming units in order to deliver information efficiently. Nielsen thinks that in his design strategy, the users' needs drive the Web site, but in fact it's the site that defines and conditions the users as consumers. Good Web design, however, reflects the users' needs and wants in all their complexity. Good design does not mold users according to its recipe; instead, it allows users to see themselves (and the process and contexts of design) in the interface.

An effective interface functions as a mirror as well as a window. *Wooden Mirror* shows this, as does *Nosce Te Ipsum.* Although HCI talks about the need to model the user, the interface should in fact reflect the user, a somewhat

Good Web design is both transparent and reflective. It reflects the user's needs and wants in all their complexity.

different and more complex undertaking. That would be true user-centered design, a strategy that reveals and reflects user, process, and context. This is exactly the metaphor in *Nosce Te Ipsum,* in which, by walking toward the screen, the user is revealed in the center of the image.

Usability testing is meant to uncover those aspects of the interface that confuse, frustrate, or otherwise fail the user. Traditional usability testing looks for the limits of transparency. It reveals those moments when the user must think about, and occupy herself with, the interface. To usability experts, such moments always indicate mistakes in the design. But they can also be moments of revelation, when the user comes to understand her relationship to the interface. Such moments are symbolized by the user's final steps in *Nosce Te Ipsum,* when all the other layers peel away and she recognizes herself on the screen.

Usability testing must come to appreciate the need for the interface to oscillate between transparency and its opposite. It must learn to measure this oscillation, which in fact defines each digital interface. The best rate of oscillation will vary for different users and different purposes. The GUI (first in the Xerox PARC machines, then in the Macintosh, and finally in the less successful Windows version) has flourished for almost three decades because its rhythms of transparency and reflectivity make good sense for most users and for a variety of applications.

Chapter 4. Magic Book

THE NEW AND THE
OLD IN NEW MEDIA

Remediation refers to
the way we borrow reality
from prior media forms.

Like the printed book, film, and television before it,
the computer is not a neutral space for conveying information.

It shapes the information it conveys and
is shaped in turn by the physical and cultural worlds
in which it functions.

Magic Book

TEXT RAIN, Wooden Mirror, and *Nosce Te Ipsum* are located in the Art Gallery itself. When we walk from the gallery into the Emerging Technologies exhibit, we see experimental designs, some of which could be mistaken for digital art. They too are radical experiments, and they too are concerned, at least implicitly, with the experience that they offer the user. Whether we call them art or technology depends on many factors, including not just the intentions of those who created the pieces, but also what institution or department the creators belonged to and who financed the work. (If the National Science Foundation or the National Institutes of Health pay the bills, it has to be technology.).

Magic Book was created by students and researchers from the Human Interface Technology Lab at the University of Washington, the ATR MIC Labs, and Hiroshima City University in Japan. *Magic Book* looks like a conventional printed book, which the reader or readers gather around, as it rests on a table. As they turn its physical pages, they can see colorful gnome-like characters and read a simple story. There is more to the experience, however. When the reader holds a special digital lorgnette before her eyes (figure 4.1), the figures and buildings in the illustrations emerge from the page and appear to her in three dimensions. The book has become a digital pop-up book (figures 4.2 and 4.3). Finally, when the reader presses on the base of the lorgnette, the scene on the page rises up and surrounds her. She can now

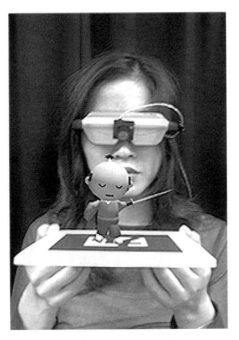

Figure 4.1

Human Interface Laboratory, ATR MIC Labs, and Hiroshima City University (Mark Billinghurst, Rob Blanding, Winyu Chinthammit, Tom Furness III, Nick Hedley, Hirokazu Kato, Lori Postner, Ivan Poupyrev, and Lily Shirvanee), Magic Book.

use a switch on the lorgnette to fly through and explore the virtual scene. She is no longer reading the book as a physical artifact; instead, she has "put on" the book and is experiencing it as a virtual reality. Two readers can share this physical and virtual book. If both are holding lorgnettes, one can enter into the virtual book, while the other continues to look at the three-dimensional image on the pages of the physical book. In this case, the first reader appears to the second as a tiny avatar within the image.

Figure 4.2
Magic Book:
Looking through the digital lorgnette . . .

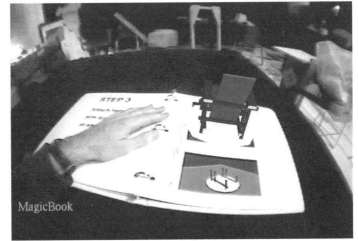

Figure 4.3
Magic Book: *. . . the user sees a computer-augmented view of the page.*

Shrunk to the size of the other characters, she seems to have become part of the story not only to herself, but to the other reader as well. She experiences the story in the first person, while the other reader experiences her in the third person.

Magic Book moves through three stages, from the physical artifact to a digitally augmented artifact to a virtual reality. The second stage is called augmented reality, in which computer graphics augment the user's view of the physical world. In this case, a video camera is attached to the special glasses, so that the reader experiences the pages of the book as a video image with computer graphics overlaid. The third is virtual reality, where the computer is drawing the whole visual scene. In this stage, the physical book disappears and is replaced by the virtual environment in which the user is immersed. When the author's style of telling the story is compelling, a printed book can metaphorically immerse the reader in the story. The Magic Book renders that metaphor visual, as the reader watches the images first rise off the page in AR and then surround her in a VR experience. Here is how the creators describe these stages:

> Readers often gather around a real storybook and are transported to imaginary magic places by the pictures and text on the pages. Similar to a normal book, people can turn Magic Book pages, look at the pictures, and read the text. . . . The Magic Book expands on the idea of a "pop-up" book by offering three-dimensional animated and interactive virtual images. If they read the book wearing an AR HMD [augmented reality head-mounted display], they see virtual images appearing out of the pages. People can read the book together in the real world and also experience the virtual images that appear attached to the real book pages. . . . Finally, readers can fly into the virtual images and experience the story immersively. Thus, the AR book allows people to experience the full Reality-Virtuality continuum. <www.hitl.washington.edu/magicbook/background.html>

The goal is to make the movement from the flat symbolic space of the printed page to the visual, three-dimensional space of virtual reality as simple as possible.

Magic Book is an experiment in what we can call remediation—the making of new media forms out of older ones. It begins as a printed book. This physical book offers its readers an experience that the designers of *Magic Book* wanted to imitate, enhance, and ultimately refashion in digital technology. Through their remediations, the designers of *Magic Book* sought to bring out the multiple levels of experience that were latent in a printed storybook.

When the designers asked themselves "What is reading?" their answer was that (at least for young readers) to read is to be transported to a world that the reader can see with

her mind's eye. The augmented reality interface allows the reader to see that world in three dimensions not with her mind's eye, but with her physical vision. The enhanced view is in turn followed and reimagined by the fully immersive experience of virtual reality. What fascinates readers of *Magic Book* are the transitions among these three versions of the book. The virtual reality experience grows out of and yet still depends on the physical book with which the reader began (figure 4.4).

Magic Book as an interface

A printed book is an interface. Read a book with a five-year-old child, and you will realize how complex and varied that interface can be. A child who cannot quite read by himself makes full use of the book's interface. Much more space is devoted to images than to text in his books; there are pictures on every page. The pictures matter, and the child wants to look at them carefully. If we are reading the text to the child, we may rush to turn the page and get on with the words (which for us is the point), but our companion knows better. He wants to savor the pictures and understand the text as an interplay of words and images. If it is a familiar book, he will probably not choose to read the pages in order. He will go to a favorite page, examine it, then perhaps move back to another favorite, and so on. Children have known for decades (since the flourishing of children's literature in the nineteenth century) how to read hypertextually. There is a long tradition of experimental interfaces in

Figure 4.4

Magic Book: (a) *Physical space of the book,* (b) *augmented reality (the physical world is seen through a computed overlay),* (c) *immersive virtual reality (the physical world is no longer seen).*

children's books—pop-up books, books in odd shapes, books with holes in the page so that the reader can see a portion of the image on the next page. In other words, children treat the book as a reflective interface.

It is we adults who have lost our imagination and insist on treating the book as transparent. Our books often have no pictures, and we (at least those of us who are not designers or editors) have learned not to care about, or even to notice, the typeface and the layout. We have learned to look through the text rather than at it. We have learned to regard the page as a window, presenting us with the content, the story (if it's a novel), or the argument (if it's nonfiction). For us adults, *Magic Book* is an experiment in the meaning of reading, a radical remediation. It reminds us of possibilities for the book as interface that we knew once as children.

Readers of *Magic Book* can move from the conventional form of the book to the immersion of virtual reality, and they can go in the other direction as well—from fully immersive to the augmented or conventional forms. *Magic Book* is an adaptive interface, which the user can set to the appropriate mode: from symbolic to pictorial and immersive (virtual reality). *Magic Book* also reminds us of the whole story of the development of the computer interface. The first interfaces on cathode ray tube terminals and on the first personal computers were text only. They were straightforward remediations of the printed page, although the printed page was much more comfortable than the twenty-four lines and eighty columns of monospaced, sans serif letters on the terminal screen. The GUI is a mixed interface—a more legible combination of text and images. And today the various attempts at immersive or natural interfaces are almost entirely pictorial.

Magic Book carries us right through the myth of transparency, offering three different interfaces, each with a unique combination of the transparent and the reflective. The paged book was the transparent interface of the past; the immersive virtual reality is (perhaps) the transparent interface of the future. Between these extremes comes the augmented reality interface, which is perhaps the most reflective of the three interfaces, precisely because it joins two forms of representation that we are not used to seeing together. We are used to reading texts in printed books; we are used to seeing moving images in movies and on television. We are not used to seeing three-dimensional moving images occupying the same space as the book. This combination makes us aware of the tension between the two forms and of our relationship to both. *Magic Book* remediates the book by suggesting that digital technology

can change the relationship of word and image, the relationship that was the focus of graphic design throughout the twentieth century.

How digital art remediates

Remediation is the making of new media forms out of older ones. When we walk back into the Art Gallery, keeping in mind the experience of *Magic Book,* we recognize practically every piece as a remediation, borrowing from and depending on other media forms. Sometimes the earlier, remediated form is the printed book; more often it is television, video, or film. *TEXT RAIN* itself combines print and video by putting both the poem and its reader into a video stream. Many of the pieces are mixed media, composed of electronic as well as analog elements.

Remediation is the making of new media forms out of older ones.

Stewart Dickson's *3-D Zoetrope* is an analog piece that simulates a digital effect—the effect of morphing. It also recalls for us attempts, in the nineteenth century prior to the invention of cinema, to make static images move. The traditional zoetrope was a cylinder lined with photographic images. When the viewer looked into the whirling cylinder, the images came together to give the illusion of movement. *3-D Zoetrope* is a kinetic sculpture in which sixty individual pieces mounted on a rotating wheel merge into a smoothly morphing image as we watch. This piece acts out as a physical sculpture what computer graphics achieves virtually through the technique of digital morphing.

3-D Zoetrope serves as a bridge between the physical and the virtual and between the present digital technology and the old technology of the zoetrope. We cannot look at *3-D Zoetrope* without thinking about computer graphics and the century of film that comes between the first occurrence of this pretty whirling cylinder and its revival. *3-D Zoetrope* asks us to consider how these technologies create the illusion of movement and which media forms we choose to explore and develop and which we choose to leave behind.

Kathleen Brandt's *Exclusion Zone* takes us elsewhere in the history of media. The piece includes three lab tables with microscopes (figure 4.5). Each microscope presents us with texts—not in the form of a printed book or pamphlet, but as text printed in miniature on microscope slides. We read these texts laboriously, one at a time, by placing them under a microscope and adjusting the knobs. Why does the artist make it so difficult for us? Because

she wants us to imitate the process by which a biologist examines the world of living cells under a microscope. This too is a new kind of reading that combines the science of medical imaging and the art of storytelling.

In the evening, we visit the SIGGRAPH Electronic Theatre, a screening of dozens of short films that showcase the latest techniques in computer animation and special effects. It is an extremely popular event, with a line that trails out into the humid New Orleans evening. In the screening, practically every short that we see is a remediation—most often of live action film, from which the animations borrow camera style, editing techniques, and conventions of plot and character. *The Last Drawing of Canaletto* is like *Magic Book* in the sense that it allows us to enter into an earlier creative work. In this case, it is not a book that is remediated, but a painting by the Venetian artist (figure 4.6). We step into Canaletto's imagined world and move around and through it.

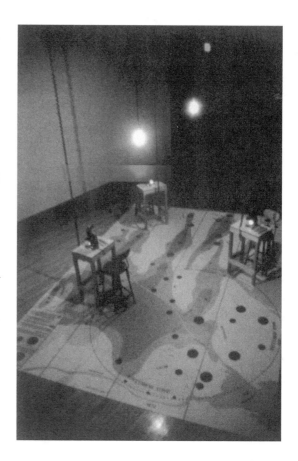

These are just a few examples of the dozens of SIGGRAPH pieces that remediate. *Wooden Mirror, Nosce Te Ipsum, Magic Book,* and the pieces we visit in following chapters (*Fakeshop, T-Garden,* and *Terminal Time*) are all deep remediations—of documentary television, painting, collage, and even the microscope. These pieces make us aware of earlier media forms in the very act of refashioning

Figure 4.5
Kathleen Brandt, Exclusion Zone: *The microscope as a medium.*

them, and it is important to develop this awareness when we set out to design digital media. As designers, we need to understand how our work functions in the history of media precisely because we are both doomed and privileged to repeat that history in our designs.

Figure 4.6
Cameron McNall, Shane Aker,
Doren Garcia, Jim Gayed, David
Hutchins, Gareth Smith, and
Jackie Stewart: Last Drawing of
Canaletto. *Computer animation*
allows the user to enter into a 3D
realization of the world of this
painting.

Borrowing reality

It is not only the computer that remediates. Each medium in general and each particular media form reconfigures and remediates others. As viewers or users, we are always being asked to compare and contrast forms. Historically, this process has been going on at least since the Renaissance, when linear perspective painting was invented, and probably much longer. Perhaps the only art that did not remediate were the first pieces of art in a culture.

Does remediation ever stop? Isn't the ultimate purpose of media forms to present the world to us? And don't we evaluate media in terms of their ability to show us what the world is "really" like? For example, television news broadcasts are supposed to present electronic images of real events as they happen—sometimes live events from thousands of miles away. In fact, however, we don't compare television broadcasts only to the physical world as we experience it. Most broadcasts show us events (such as earthquakes and wars) that we will never experience if we are lucky. We generally compare television news to other television broadcasts and to other media forms, such as newspapers and (now increasingly) Web sites. Sometimes television news even acknowledges that it is covering itself covering the news. During the Persian Gulf War in the early 1990s, CNN seemed to have the best coverage, with

reporters on the ground in Baghdad and Israel as well as with the U.N. coalition. The other networks simply broadcast CNN's reporters live; they were reduced to remediating CNN. The war itself was (for us, not for the combatants) a media event, and the fact that CNN's reporters remained in Baghdad became part of the war story itself.

Such ironies are not new. Throughout modern history, media have been understood and appreciated precisely because of their reconfiguration of an earlier medium. Whenever a new media form is introduced, there is an inevitable rivalry with other forms to prove which can offer an experience that is authentic. The enthusiasts for a new medium (photography, film, television, virtual reality) want to believe that it will allow them to experience events and people just as they would experience them without any media at all. The irony is that this claim to reality usually depends on earlier media forms. Photography supposedly finally got linear perspective right, but linear perspective had been defined centuries before by Renaissance painters. Film represents motion by recording a series of still photographs and playing them back at a rapid rate. Television depends on a similar trick, although in this case, it claims to surpass film because television images can be broadcast "live." In each case, techniques of earlier media were borrowed and reconfigured. Photography reconfigured elements of landscape and portrait painting; film reconfigured techniques of stage drama; television borrowed from conventions of vaudeville, stage drama, and film. Throughout the history of media, the context has been one of rivalry to create an "immediate" or "authentic" or "compelling" experience.

This rivalry is expressed in the work of individual artists, designers, technicians, and inventors. Remediation has been part of almost every design strategy in the modern era. Some designers have intentionally and explicitly remediated earlier media; others have done so implicitly and perhaps unconsciously. Once we understand this historical process, we can see how digital applications, especially Web and Internet applications, offer opportunities for remediation as an explicit design strategy.

Media forms

The computer is not a neutral space for conveying information any more than the printed book, film, or television are neutral. The computer shapes the information it conveys and is shaped in turn by the physical and cultural worlds in which it functions. For this reason, the computer is more than what Claude Shannon defined in his communication theory—more than a pipeline that channels the content from sender to receiver. As they have done with

books, film, and television, designers use the computer to give shape to the content that it transmits; they transform the delivery of content into an experience of a particular kind. Furthermore, digital technology is not a single medium, but rather a network of related media forms.

The computer is not a neutral information space: it shapes the information it conveys and is shaped in turn by the physical and cultural worlds in which it functions.

The World Wide Web has already produced many such forms, each with its own conventions and its own audience. For example, there are news and information Web sites modeled on newspapers and television, and in fact the major newspapers and television news organizations all have their own Web sites. We expect such sites to offer a layout with a menu bar on the left and information area on the right (figure 4.7). Such an information site typically operates through a series of subject links, usually in the navigation area on the left. We expect the sites based on newspapers (such as the *New York Times on the Web*) to offer stories taken from the printed newspaper or written in a similar style. We expect the sites based on television networks (like CNN.com) to include video clips along with the articles. These expectations come from our knowledge of these media forms.

The same is true of our experience of earlier media forms. When we read a novel, we have expectations about the "interface"—the way the text is laid out on each page and page by page. We have expectations about the shape of the novel as well—how the story is told with one or more narrators, how time moves in the telling of the story, how characters interact. The novelist may experiment with these expectations. He may break some of the conventions, but he cannot ignore them entirely. In the same way, for many digital applications we have expectations that have already arisen from our experience with digital genres.

Figure 4.7
Standard design for an information Web site, with menu bar on left and information area on right.

There are Web radio and television stations, Web soap operas, sites to promote and advertise corporations and organizations, official and unofficial fan sites for celebrities, gambling and pornography sites. Audiences already know how to read these various media forms, how to tell good sites from poor ones. The same is true of computer games delivered on CD, DVD, or over the Web. Already, the fans of such games can draw subtle but (to them) important distinctions among the various subgenres: action, adventure, role playing, simulation, puzzle, and so on.

Remediations are not forever

In 1945, American radio was thriving with different media forms for drama, comedy, and news and information. Other than a few enthusiasts for television (who must have sounded rather like VR enthusiasts do today), no one thought that within fifteen years, these forms would all but disappear. Between 1951 and 1956, longstanding favorites such as *The Life of Riley, The Shadow, The Adventures of Ozzie and Harriet,* and *The Lone Ranger* went off the air. (*Gunsmoke* lasted until 1961.) Television didn't kill radio, but it killed radio as a medium for telling stories. Many of the qualities of radio entertainment were taken over by television in the 1950s, and many radio series, such as *The Lone Ranger, Amos and Andy,* and *The Adventures of Ozzie and Harriet,* migrated to television.

Media forms and even media can become moribund and can be replaced. Radio continues to spawn new forms: the pseudo-political talk show, endless subtle varieties of popular music programming, the non-news news format (where reports of traffic jams and local thunderstorms are treated as news items). These too are remediations—of the Hyde Park (eccentric) orator, the disco dance, and the gossip once exchanged in barbershops. And there are the interesting hybrids: radio broadcast over the Web, music downloadable from the Internet, and so on. But media forms for narrative and drama hardly exist on broadcast radio anymore.

Remediations are always provisional. Because remediation, like beauty, is in the eye of the beholder, the task of the designer is to convince the user of the value of each remediating design. When designers succeed, new media forms are born. But a new form is not better in any absolute sense than the older form. It depends on what criteria we use to judge the new and old forms. Designers and producers of the new form want the audience to adopt new criteria. Television programs are better than the experience of film only if we measure the two forms by the standard of "liveness." Television news is more up-to-date and therefore (by

some standards) more informative than the film newsreels that used to run in theaters in the 1940s before the feature presentation. If we measure by the quality of the image, however, film was always and is still better (as we wait for HDTV). Web sites are better than television if we judge them by the standard of point-and-click interactivity. But television is still better than the Web at delivering higher-quality moving pictures in real time. The key is which standard is applied.

In digital design, the standards seem to be changing more rapidly than ever before. Everything about digital design is in motion, including the criteria by which we judge it. The standards for judging a printed book—the transparency of the layout and typography— remained much the same from 1600 to 1900 and beyond, although there were changing ideas about how to achieve that transparency. But with the new media of photography, then film, radio, and television, the criteria changed several times in the space of 150 years. Today, digital design is at most 30 years old, and the criteria seem to change often, as digital technology is presented as a rival to different earlier media and their forms. First, the computer was a new kind of book, then a new kind of graphic design, and now also a new kind of television and film.

The variety of digital remediations

In a sense, electronic computers started to function as remediators as soon as they were tinkered together in the 1940s. They were built to remediate the mechanical calculating machines and the card tabulators that had been used since the turn of the twentieth century to record the U.S. Census and similar data for business. It was these tabulators that made IBM an important company before electronic computers were ever built. The early electronic computers used punch cards or punched paper tape as input and sometimes as output. What they remediated was what happened between input and output: they replaced the mechanical operations of sorting with electronic comparisons. We did not see this replacement as a remediation, however, because we did not understand the computer as a medium at all. Instead, in the early years, we were captivated by the idea of the computer as an electronic brain rather than as a medium of representation. Although the computer was already a remediator in the 1940s and 1950s, our culture did not get the point until much later, when we began to see how the computer could explicitly supplement or replace other media forms.

It is no coincidence that the researchers at Xerox PARC, such as Alan Kay, who finally and convincingly demonstrated that the computer could be a medium, also introduced the

great remediating metaphor: the computer as a secretary's desktop in a business office. The paper files and folders of the physical desktop become electronic files and directories in the computer, and the user places files into folders by manipulating them with the mouse. It is a good metaphor. Usability experts tell us that a metaphor is or should be operational: that it should make it easier for the user to go through the steps required to accomplish a task in information management.

Metaphors, however, have a larger purpose, precisely because the computer is now understood as a medium. A digital metaphor should explain the meaning and significance of the digital experience by referring the user to an earlier media form. There does not have to be, and indeed there could not be, a perfect correspondence between the operations of the computer and the work of a secretary seated at a desk. The historical importance of the desktop metaphor was that it explained what the new personal computer was good for. It explained that unlike the behemoth mainframes of the past, these computers were meant for the work that secretaries, businesspeople, writers, and academics used to do with pen, paper, and typewriters. (And although it has not eliminated pen and paper, the personal computer has almost eliminated the typewriter.) The desktop metaphor obeyed the double logic of remediation: it depended on the importance of past media, and yet it asserted that the computer could improve on the past.

The desktop metaphor incorporated, rather inconsistently, an earlier metaphor that Douglas Engelbart developed and Alan Kay had perfected. As we have noted, the display of information in separate, movable, overlapping rectangles on the screen could have been given a variety of names, but developers chose the name *window* and so invoked a cultural metaphor that goes back to Renaissance painting. Today, computer windows can replace not only paintings, but potentially other media forms such as printed books, to offer us a view onto a world of information. The first computer windows held only blocks of text; now, especially with the prevalence of the World Wide Web, computer windows contain static and moving images as well. They offer experiences and not mere data, and they constitute the principal unit of digital design on the desktop computer.

Although its windows are (sometimes) meant to be transparent, the computer itself is anything but transparent today. We see computers and computational devices all around us; they are the most visible and obvious examples of a media revolution. Furthermore, the computer has now emerged as perhaps the most vigorous and eclectic remediator of all the various media that we still use. Various digital forms, and particularly the World Wide Web,

borrow from, reconfigure, and remix all of the principal media of the twentieth century (film, radio, audio recording, and television), as well as two great earlier media: photography and print itself. All of these were new media themselves at one time and defined themselves in distinction to earlier media.

Like their predecessors working in graphic design, photography, film, and television, digital designers are becoming used to borrowing from earlier forms. Digital art has the important task of explaining how this bor-

Computers and computational devices are the most visible and obvious examples of the media revolution.

rowing works: we borrow in order to offer a new experience for the viewer or user, but that experience always depends on our remembered sense of the reality or authenticity of earlier forms. The magic of *Magic Book* lies in the way it recalls our childhood belief that the stories that books tell are real worlds—worlds that we should be able to explore and inhabit.

Magic Book is nostalgic in this sense. It is striking how many digital designs, particularly Web sites, make a nostalgic appeal to "simpler" technologies from "simpler" times. For this reason, radios and television sets, jukeboxes, photo albums, and control panels with quaint analog displays are all popular metaphors on the Web.

Metaphors and remediation

A digital metaphor may be a navigational tool, but at the same time it shapes the user's experience of the site. This is the way to think of navigation in general: it is not simply the movement between units of information but an experience. To design the navigation and interaction strategies of a Web site (or any computer application) is in large part to define the user's experience of the site.

Usability experts claim that designers use metaphors too freely. A metaphor, they argue, can be misleading if users fail to understand its limits. In fact, digital metaphors are never perfect analogies, and users soon realize that they are not meant to be. If the computer desktop was perfectly like a physical desktop, folders would be as hard to rename and reorganize in the computer as they are on a physical desk. Texts of letters and other documents would be as hard to change. Why would anyone then bother to buy a computer to do word processing and file organization? The purpose of a good design metaphor is to emphasize differences from as well as similarities to the original. The divergences from the metaphor are

part of its meaning, because they show the ways in which the computer application improves on the original. This is especially true when the metaphor is to another medium, when the computer interface is a remediation of an earlier form.

In our media-saturated culture, it is inevitable that we should understand Web sites, computer games, or even productivity tools in comparison with other media. We make these comparisons so quickly and automatically that they become almost unconscious. That is why we love metaphors and computer icons, even when usability experts tell us that both are overused.

The rhythms of remediation

Suppose you had invented a new medium—a technology that transmitted and created experiences in a way unlike any other. A friend comes to you and asks what your invention is for. What do you say? How could you describe it without referring to other media? You would have to say: "It's like television, only you view images in three dimensions on a headset." Or: "It stores symbolic information like a printed book, except that the reader can change the information." You have to tell people how it fits into the ecology of existing media forms. Until you can explain how it resembles and how it surpasses other media, people won't recognize it as a medium at all.

This very thing happened with the computer. For the first several decades, people did not understand the computer as a medium. It became a medium only when Licklider and Kay began to explain how it could combine the functions of the book, the telephone, the painter's canvas, and so on. They had to indicate what was familiar about the new medium in order to indicate what was different. Each designer of a new media artifact in effect does the same thing: defines a rhythm of the old and the new and makes that rhythm intelligible to the user. If the artifact is a perfect replica of an older form, the user will see no need for it. And if the artifact is utterly and completely new, the user will not understand what it does or why he should learn it.

The rhythm of remediation is another name for the rhythm discussed in chapter 3: between the transparent and the reflective. Because the user is accustomed to the earlier medium, it seems transparent and natural. Why design a news and information Web site to look like a newspaper? Because a newspaper is still seen as the "natural" way to present news. Put a story in a multiple-column format with headlines and bylines, and people will regard it as news (as newspapers themselves prove every day by running stories that tell us nothing of local, national, or international significance). The very fact that these stories appear in the

proper format qualifies them as news. The stories on the news and information Web sites often follow the same structure and present the same content as in newspapers. What is new and (at least at first) unexpected is that Web sites can present links that allow the user to jump to other stories. Hyperlinks are reflective elements in the interface: they compel the user to consider where the link might take her.

Remediation as a conscious design strategy

The rhythms of the old and new will be different for different sites, depending in part on whether the remediation is explicit or implicit—for example, whether the site looks and acts like a television or simply recalls the medium forms of television broadcasting implicitly in the way it addresses the user. But the borrowing of older media forms always has a double sense: it both honors the older forms and challenges them. The borrowing helps explain a new technology to its users. One piece at SIGGRAPH 2000 says to its users, "This virtual reality application is like a book in the sense that it imagines a world for you to experience. At the same time, it improves on the book by allowing that world to surround you as a visual experience." Another says, "This Webcam site is like a television show, but with the advantage that you as the viewer can decide which camera view to watch and when to switch."

Digital design should take this lesson from digital art: designs, as media experiences, borrow a sense of authenticity or reality from previous media forms. Like digital art, commercial designs borrow from earlier forms in order to claim to improve on them. Whether she is working on a Web site or the interface for a new word processor, the digital designer is remediating some earlier forms. Likewise, the user will be consciously or unconsciously comparing her site or interface to earlier media. He will be trying to read a Web site as if it were a print publication, he will read the graphics as if they came in a magazine, or he will read the streaming video as if it were a television broadcast. As it was for the artists of SIGGRAPH 2000, the strategy of remediation should be a conscious part of design, especially now that we understand the computer as a medium that can offer us new media forms. The poet and critic T. S. Eliot said that good poets borrow and great ones steal. We could say that all designers remediate and good designers do so consciously and consistently.

Chapter 5. Fakeshop
THE DIVERSITY OF NEW MEDIA

New media is not one media form,
but a series of convergences—a series of
temporary and provisional combinations
of technologies and forms.

Fakeshop

In the SIGGRAPH Gallery, the *Fakeshop* project is represented by an elaborate Web site. We see multiple windows, offering streams of information (text, stills, and video), reported through a richly layered interface. As the artists (Jeff Gomperz, Prema Murthy, and Eugene Thacker) explain, "This work is the result of a fascination with aesthetic by-products of computer procedure. It is an example of electronic audio/visual transfer (CUSeeMe video-conferencing, Real Audio broadcasting, and other assorted hi/lo tech tools.) We've endeavored to build an electronic theatrical device, to create conditions in which simultaneous transfer of digital information can occur in real time" (*SIGGRAPH 2000*, 42).

The site at SIGGRAPH 2000 is a collage of different times and places, and it is one expression of the larger *Fakeshop* project. Fakeshop is a team of artists whose work combines installation, Web, and performance elements. The installations themselves took place in Brooklyn during summer 1999 and at Ars Electronica in the fall. The experience offered was both physical and virtual: it was an exhibit that a user could enter and explore, and it was a Web presence. The Web page in figure 5.1 shows the many threads of the experience.

The window in the left corner comes from *Coma,* a dystopic 1978 science-fiction movie, in which victims are kept in a coma in order to harvest their organs. The *Fakeshop* installation is a remediation of a scene from the movie, in which live actors lie on futuristic

Figure 5.1

Jeff Gomperz, Prema Murthy, and Eugene Thacker, Fakeshop Web site: The diversity of new media forms.

platforms pretending to be comatose. Visitors to the installation can walk among the actors, who remain perfectly still. Meanwhile, video cameras are streaming images of the comatose actors over the Web; one such image appears at the lower left of the Web page. Other images and texts occupy other windows on the page. The text window, for example, holds excerpts of appropriate texts as well as logs of chats recorded from past performances, as people from around the world were invited to log in using CUseeMe (videoconferencing software) and contribute to a live discussion. All of this material is collected on the Web site, which is projected on a wall of the installation and can also be viewed by anyone browsing the Internet.

Fakeshop is about the human body as a physical presence and about the representations of our bodies that we send through cyberspace. On the Web site, we see bodies as envisioned in a film, bodies of actors recreating the film, and 3D models of the body (rendered in a graphics program called Poser). We read texts that describe what is happening to our embodied existence in an age of information. The diverse ways in which bodies are presented and represented illustrate the diversity of media and media forms surrounding us today. Even the "live" bodies of the actors were, after all, part of a media event, an electronic theater piece.

Fakeshop borrows and refashions most of the media that we now find on the World Wide Web. As viewers (or users or participants) of the site, our attention is drawn successively in many directions: toward the text, the images, and particularly the digitized video appearing in the windows, and then back to the windowed interface itself. The interface itself is a collage of media forms.

Other pieces we have visited—*Nosce* and *TEXT RAIN*—have the quality of collage. *TEXT RAIN* is diverse in the sense that it combines two distinct media, the book and the video camera, that were at odds with each other throughout the second half of the twentieth century. (Readers over the age of thirty will remember how television was often blamed for the decline in print literacy in the United States, although the truth is that the United States has not been a very literate society since the nineteenth century, if it ever was.) The World Wide Web and computer games, the new villains for traditionalists, are now sharing the blame with television. Digital art in general is extremely diverse, reviving old and even archaic media forms and at the same time exploring the newest technological possibilities (such as genetic programming, virtual and augmented reality, and artificial life).

Digital art is not concerned about being pure. It often mixes the virtual with the physical, as does *TEXT RAIN,* which as an installation consists of both the physical presence of the participants and their projected images on the screen. The diversity of digital art reflects the diversity of the digital world, which, despite predictions, shows no sign of converging to a single medium or media form. Far from unifying all media into one, digital designers and entertainment corporations are busy devising new combinations of older forms. The closest thing we have to a converged medium is in fact the World Wide Web, already a complex mix of forms and audiences.

The myth of convergence

Digital technology may not have converged, but the predictions of the enthusiasts have. When they describe our digital future, it almost inevitably comes down to interactive television. Viewer-users will sit in their family room converged around a wall-sized, high-definition television screen and "interact" with the shadows on the wall. If they are watching a drama, they will be able to switch points of view, follow their favorite characters around, and influence the story. If they are watching news, they will be able to choose among the stories, as well as the amount and kind of background information, they receive. They will participate in local, national, or global forums and make their opinions immediately known through electronic voting. They will visit electronic shopping malls and make purchases. The predictions are utopian and, for some, breathtaking. Despite decades of experimentation and promises, however, no interactive television system has proven workable or popular.

On the other hand, so-called enhanced television has been a surprising success. In order to enjoy enhanced television, the viewer must set up a traditional computer and a television in the same room (or be willing to watch television in a window on her computer screen). Before, during, or after the show, the viewer can visit a Web site. For a sports show, the site might offer additional statistics and background information. TBS might enhance its fortieth rerun of a James Bond movie by offering a trivia quiz on its Web site. Real-time enhanced television demands that viewers split their attention. They cannot concentrate exclusively on the television broadcast, but must oscillate between the computer screen and the television screen. Enhanced television is therefore not the unified experience promised by interactive television, where the interaction is supposed to involve the viewer more deeply in the content of the broadcast. In enhanced television, the user cannot change the plot or experience the story from different points of view, techniques that have been proposed, but never successfully implemented, for interactive television.

Although enhanced television is clearly not for everyone, there are apparently millions of viewers who are willing to divide their attention in this way. Instead of the transparent experience promised by interactive television, these viewers prefer the self-conscious experience of moving back and forth between two different forms in different media. But enhanced television doesn't have to be for everyone. Millions more viewers can continue to experience television without visiting a Web site. Unlike interactive television, which would completely replace linear broadcast television and movies, enhanced television is a provisional

design solution that coexists with the traditional form. It is a reflective design, and reflective designs are by nature tolerant of other forms because they do not require the user's undivided attention or complete allegiance.

So while enthusiasts continue to plead for the total solution of convergence, enhanced television illustrates what really works. In general, instead of a single convergence of all digital technologies, what we are witnessing is a series of convergences—provisional combinations of technologies and forms. We have general-purpose desktop computers (still with us in the tens of millions); laptops that play DVD movies; handhelds and palmtops that combine notebooks, clocks, and calendars; electronic books (computers that you really can take to the beach or read in bed); MP3 devices that receive music downloaded from the Internet; and cell phones with Web browsers and e-mail.

We are witnessing a series of convergences—provisional combinations of digital technologies and media forms.

Designers and companies have arranged a kind of dance in which all the various underlying technologies (central processing units and memory chips, cathode ray tubes and liquid crystal display screens, hard drives, DVD drives, keyboards, graphics hardware and software, handwriting recognition software, Ethernet cards, modems, and so on) come together to form new devices and interfaces. Some of these devices catch on and begin their own course of development; others disappear. Other designers and companies may split and reformulate the elements to create still newer devices. The desktop computer itself combined the television screen, the typewriter keyboard, and the central processor on a chip (or a small set of chips). Designers then shrank the desktop computer to create the laptop. They shrank the laptop again and removed its keyboard to give us the palmtop. (In the process, they changed the design model from the typewriter to the notebook, from typing to handwriting.) Then, taking the printed book as a model, they enlarged the display of the palmtop, simplified the interface, and created the electronic book. While all this was happening, between 1980 and 2000, telephones (both fixed and mobile) began to acquire small LED (light-emitting diode) screens to allow access to e-mail and the Web.

Convergence is a myth—a story that designers and digital promoters tell themselves and us. There are more and less convincing versions of the convergence myth. The more

convincing ones (such as enhanced television and the mobile phone) capture the provisional and specific nature of digital convergences.

Diversity on the World Wide Web

As the most popular expression of digital media, the World Wide Web also shows how digital convergence really works. The Web combines most, if not all, popular media and media forms: the magazine, newspaper, graphic design for advertising and display, various forms of photography, and, more recently, radio, film, and television. Web designers are creating new forms from these borrowings, not a grand, single converged form. The Web itself has diverged or divided into many different forms, each serving a particular audience of thousands or millions. Web forms have found various niches, based on the needs and expectations of these audiences and on the various delivery platforms.

Although both HCI experts and designers acknowledge the diversity of the Web, few in either camp seem willing to accept the consequences of diversity. They still want to articulate a set of design rules that are universal, even though the universe of the Web is too varied to fit comfortably into any one scheme. Their mistake is to assume a single kind of user with a single goal.

Jakob Nielsen's user is a customer, who visits the Web to buy something. In *Designing Web Usability* (2000), Nielsen writes, "The Web is the ultimate customer-empowering environment. He or she who clicks the mouse gets to decide *everything*. It is so easy to go elsewhere; all the competitors in the world are but a mouseclick away" (9). And later: "While I acknowledge that there is a need for art, fun, and a general good time on the Web, I believe that the main goal of most Web projects should be to make it easy for customers to perform useful tasks" (11).

Nielsen's users are none other than the rational consumer units that economists long ago recognized as an inadequate description of human beings, even at their most economically driven. If a Web page takes ten seconds to load, then Nielsen's users will try a competing site that is only "a mouse-click away." They are not interested in having an experience. Because they prize efficiency above all—to get prices, make a transaction, and then be off to another site—they prefer the transparent delivery of information to attractive graphics. The curious thing about Nielsen's vision is that he sees the Web as a consumer media form but seems to ignore the earlier consumer forms of television and magazines. Television and magazine advertisements

have shown that creating an experience can be the key to commercial success. Advertisements certainly do not provide a transparent view of the product or service being offered, and both television and magazines have been rich fields for creative designers. Graphic design, after all, was born (in the United States at least) in the late nineteenth and early twentieth centuries out of the need for companies to promote the mass consumption of their products.

In *Creating Killer Web Sites* (1997), David Siegel's Web users are also consumers. They too are on the Web to purchase something, but like television viewers or magazine readers, they respond to visual design. They will succumb to a Web site that provides the proper experience, but they demand perfection. Although they expect graphics and a high-concept design, they too are unwilling to wait for long download times. If a pixel appears out of place or a color gets remapped, they will go elsewhere.

Even Siegel refuses to acknowledge adequately that the diversity of the Web audience demands diversity of design. There are few rules of Web design that can apply across the whole spectrum of Web users. In this sense, the Web is infinitely more diverse than broadcast television or radio, which must operate within quite narrow parameters. For example, thirty years ago, the media theorist Raymond Williams described the concept of flow on television—how a continuous stream of programs and commercials washes over the viewer. Has the concept of flow really changed in the intervening decades? Different, more frenetic rhythms are now possible, but would any one of the (traditional or cable) networks intentionally program even three seconds of dead air?

What design principle could we define for the Web that is similarly unbreakable? No graphics larger than 50K, 100K? A digital artist may choose to show larger graphics on her gallery site. And in fact the most commercially profitable Web sites, pornography sites, have users who will pay for the privilege of waiting several minutes for a particularly "graphic" download. (By the way, pornography sites violate every design rule you can name. They feature illegible fonts, misplaced graphics, grotesquely textured backgrounds, hard-to-find links, misleading banner advertising, multiple pop-up windows—and yet their users continue to pay to visit them. They are definitely not Nielsen consumers.) No single page should be longer than one or two screenfuls? But scientists and scholars often use the Web as an archive for their papers, which they load into a single page. This simple format is perfectly adequate for their colleagues, who want a quick printout. Project Gutenberg provides classic literary texts in this format; you can get all of Conrad's *Heart of Darkness* on a single web page (figure 5.2). On a

Figure 5.2
Project Gutenberg, Heart of Darkness: *Entire text on a Web page*
<sailor.gutenberg.org/pub/gutenberg/etext96/hdark10a.txt>, July 5, 2002.

broadband connection, the download takes only seconds. However, a scholar would clearly be willing to wait for several minutes (or hours) to get a machine-readable copy of a text if he wants to do some textual analysis to test a theory. No flashing text? A site for children might break even this rule successfully. (And again, there are the pornography sites.)

Perhaps the only rule is that the design of each site should suit its envisioned community of users. It should establish a rhythm that corresponds to their needs. To achieve this rhythm, a site may emphasize transparency or be more reflective. Each Web genre, each site, and to an extent each page will define its own convergence, its own combination of old and new media forms. The multiplicity of the Web is in part (but only in part) due to the increasing divergence of the platforms on which we can now browse the Web. We can now view sites on everything from a giant projection television to a cell phone. We should not forget the traditional desktop, which provides better resolution and color than the giant screens.

Still, it seems that in the future, we will be doing more of our browsing on smaller portable devices, as the trend toward ubiquitous computing continues.

Bricolage at SIGGRAPH 2000

On and off the Web, the commercial successes (and failures) of the previous decades show that digital design is the practice of putting disparate elements together in new ways. Any one configuration of elements may be temporary. The French word *bricolage* has been used to describe this practice among postmodern artists and designers. Bricolage is the art of putting things together with the materials that happen to be at hand, and even when it is carefully planned and meticulous, digital design has the feel of bricolage. One reason is that the materials of digital design (the digitized forms of earlier media) change rapidly as technologies mature. A few years ago, for example, digital video was rare on the Web because of bandwidth limitations; it promises to be ubiquitous soon. Another reason is that digital designs do not often integrate the elements of earlier forms fully or seamlessly. Like digital artists, computer researchers working to create new technologies are also *bricoleurs*. To test concepts, they put together software and hardware in a provisional fashion, employing libraries of code written by others, adding code here and there, and often building their own helmets, trackers, and vision systems. They are tinkerers at heart.

At SIGGRAPH 2000, bricolage is everywhere in evidence. There is Elliot Peter Earls's frenetic performance piece, *EYE SLING SHOT LIONS,* which Earls himself describes as "a melange of typography, sound, video fragments, interactive digital video, simulated live performance, short films, and pop music" (*SIGGRAPH 2000,* 41). Each performance is "occasional"—a selection of elements to suit the particular conditions of that performance and occasion (figure 5.3).

The interactive installation by Rania Ho has the unexpected title *Free Range Appliances in a Light Dill Sauce* (figure 5.4). Ho calls this an "an irreverent look at the meaning of 'smart' appliances," in which "kitchen appliances are liberated from their mundane existences and taught motor skills so they can fully realize their suppressed ambulatory desires" (*SIGGRAPH 2000,* 46). Motorized toasters, egg beaters, and kettles wander around in a fenced area attracted to and repelled by each other. The appliances on wheels certainly have the appearance of being tinkered together out of spare parts. These "smart" appliances are in search of a mission, embodied parodies of the concept of the information appliance.

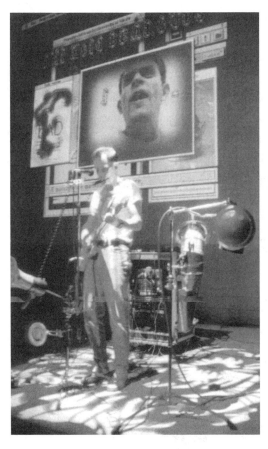

Figure 5.3
Elliott Peter Earls, EYE SLING SHOT
LIONS: *The performance piece as collage.*

Figure 5.4
Rania Ho, Free Range Appliances in a
Light Dill Sauce *(mixed media, 2000):*
Bricolage as art.

And what could be more provisional than
TEXT RAIN, in which the user herself is invited to
become a bricoleur by making temporary meaning
out of the letters that happen to fall?

The bricolage of SIGGRAPH 2000 shows how the myth of convergence is another version of the myth of transparency. Media gurus who tell the myth of convergence assume that media should always become naturalized and disappear. The converged medium in the future is ultimately supposed to be transparent, which is why the ultimate medium is usually supposed to be a giant high-definition TV. Enthusiasts describe high-definition, interactive television as a

medium we can look right through, a window onto a world of pure experience. The pieces of SIGGRAPH 2000, however, don't fit this description. Disparate and diverse, they call attention to themselves. We can't simply look through them, because they are reflective, and what they reflect is the relationship between the old and new media forms that they combine.

The enthusiasts for convergence do not expect the digital interface to work in this way; they expect that users will grasp the converged medium automatically and without reflection. Yet this doesn't happen with the art of SIGGRAPH 2000. It is not that these pieces are always "difficult" or esoteric. Many of them (*TEXT RAIN, Wooden Mirror, Terminal Time*) appeal to a broad audience of artists, computer experts, designers, and many others. Nevertheless, the pieces refuse to converge to a single, simple media form, because that is not the direction in which our digital culture is heading.

Where we are heading instead is toward ubiquitous computing.

Ubiquitous media

Mark Weiser's pioneering work in the early 1990s added a new term to the digital lexicon. In a *Scientific American article* in 1991, he predicted:

> My colleagues and I at PARC believe that what we call ubiquitous computing will gradually emerge as the dominant mode of computer access over the next twenty years. . . . When almost every object either contains a computer or can have a tab attached to it, obtaining information will be trivial: "Who made that dress? Are there any more in the store? What was the name of the designer of that suit I liked last week?" The computing environment knows the suit you looked at for a long time last week because it knows both of your locations, and, it can retroactively find the designer's name even if it did not interest you at the time. Ubiquitous computers will help overcome the problem of information overload. There is more information available at our fingertips during a walk in the woods than in any computer system, yet people find a walk among trees relaxing and computers frustrating. Machines that fit the human environment, instead of forcing humans to enter theirs, will make using a computer as refreshing as taking a walk in the woods. (104)

Weiser drew a contrast between ubiquitous computing and virtual reality:

> The opposition between the notion of virtual reality and ubiquitous, invisible computing is so strong that some of us use the term "embodied virtuality" to refer to the process of drawing computers out of their electronic

shells. The "virtuality" of computer-readable data—all the different ways in which it can be altered, processed and analyzed—is brought into the physical world. (98)

"Embodied virtuality" recognizes the fact that digital designs intersect with our physical world: they cannot escape from it into pure cyberspace. While VR (virtual reality) seems to eliminate the computer, as it takes the user into a graphic world, ubicomp (ubiquitous computing) or embodied virtuality does just the opposite: it scatters computational devices throughout our environment. With ubicomp, the computer joins us in our physical world; with VR we join the computer in its world. Ubicomp recognizes the divergence and diversity of design; VR wants to be the ultimate convergence. Ubicomp seems to be winning. Although VR has proven useful for specialized applications, we are not any closer today than we were in 1990 to a general 3D, immersive interface. Meanwhile, computational devices continue to multiply, and we continue to purchase and surround ourselves with them.

> **Digital designs intersect with our physical world; they cannot escape from our world into pure cyberspace.**

But Weiser got one thing wrong. Even while he was drawing a contrast between virtual reality and embodied virtuality, he insisted that ubicomp too would be invisible computing. His *Scientific American* article began, "The most profound technologies are those that disappear. They weave themselves into the fabric of everyday life until they are indistinguishable from it. . . we are trying to conceive a new way of thinking about computers in the world, one that takes into account the natural human environment and allows the computers themselves to vanish into the background" (94).

Media are among the most profound technologies, and they do not disappear. Instead, media and their forms oscillate between being invisible and visible—between being windows and mirrors. When media become visible, they become mirrors, reflecting the world around them, the contexts in which they function.

The ubicomp enthusiasts show a great interest in the information processing of everyday housekeeping tasks—smart refrigerators, toasters, doors, windows, and thermostats all talking to each other. While there have been a certain number of these "free-range appliances," our culture is far more interested in ubiquitous media devices: digital cameras, MP3 players, and mobile phones. Most digital devices with which we now surround ourselves are

functioning as media forms, representing the world to us and sending these representations back and forth through twisted pair, coaxial cable, fiber optic cable, or through the "luminiferous ether."

Media are everywhere today—in our living rooms, bedrooms, dens, and kitchens. They follow us when we leave the house—not as free-range appliances, but under our close supervision. Our cell phones accompany us everywhere, while radios, cassette decks, CD and DVD players, and sometimes even navigational computers travel with us in our cars. And when we reach our destinations—offices, malls, restaurants, bars—we find that many of these same media are already there as well. In offices, assistants and their bosses listen to the radio while working at their word processors. Many of us now seem to prefer both working and leisure environments in which two or more media forms compete for our moment-to-moment attention. It's no wonder writers on media are convinced that attention is the most important currency in the information economy.

The World Wide Web is the perfect example of a complex of new media forms driven by competition for our attention. E-commerce on the Web is all about attention, because at any moment (as Jakob Nielsen reminds us) the user can click on a link, choose a menu item, or type in a URL, and fly off to another site. Web advertisers talk about "buying and selling eyeballs"—trying to convince the user to lend her attention to their banner advertising and click through to their site. The Web also contributes to our hypermediated environment by morphing into a combination of media forms: text, graphics, animation, audio, and video. Competition for attention is the ultimate motive behind remediation—competition not just between various instances of the same form (various television channels) but also between forms from different media (for example, between television and Web sites or between movies and computer games).

On the Web and elsewhere, ubiquitous computing has become ubiquitous media. We want more media forms on more varied devices. In many cases, these devices are portable, and in some cases, we are even prepared to wear them.

Wearable media forms

Wearable computers are more than 400 years old. Admittedly the first wearable computer, the wristwatch, whose basic design and purpose was relatively unchanged from the sixteenth century to the twentieth, was an analog device. The wristwatch set a standard to which all

current wearable computers are (usually implicitly) compared. Meanwhile, the clock (portable or fixed) was the prototype for the entire mechanical technology that dominated Europe and then North America from the Middle Ages to the arrival of the integrated circuit. Before there was ubiquitous computing, our society experienced hundreds of years of ubiquitous mechanization, as people surrounded themselves with mechanical devices.

We might think that the watch is a perfect example of a transparent information technology—its purpose to indicate the time as quickly and efficiently as possible. Yet we also know that a watch not only tells the time; it also makes a fashion statement and tells us something about the wealth or poverty of the wearer.

From the eighteenth century to the mid-twentieth, the Swiss were the best watch-makers. No one could match the perfection of the Swiss mechanism. When the American manufacturer Bulova began marketing the Accutron, a watch with a quartz controller, in 1960, the Swiss smiled and continued to construct their beautiful and precise mechanicals. But quartz watches instantly began to win every contest for accuracy. Rather than admit defeat, the Swiss simply declared an end in Switzerland to accuracy contests in the wristwatch category (Landes, 1983, 346). Quartz watches and then fully digital watches proved in the coming years that the mechanical clockwork mechanism was utterly obsolete. The digital watch delivered information more cheaply and so much more accurately that there was no reason for anyone ever to own a mechanical watch. As we know, no one wears a mechanical watch any longer . . .

Well, in fact millions of people continue to wear watches with mechanisms or at least analog displays. What saved the Swiss industry was the realization that it was not only selling time; it was selling a design. The Swiss (and others) developed ever more elaborate and expensive designs that people could display as marks of wealth. They developed the Swatch line to sell a lifestyle, rather than a wristwatch, just as the Coca-Cola company sells a lifestyle rather than brown fizzy water.

The Rolex and the Swatch are interfaces that are obviously and emphatically not meant to disappear. They are meant to be seen and appreciated not only by the user but by his acquaintances as well, with each design appropriate for a certain social group or a certain fashion context. In general, retro designs and advertising have worked so well that analog watches are considered cool, and digital watches are often regarded as appropriate apparel only for geeks. However, digital watches are clunky and uninteresting only when they appear

to pursue transparency. The strategy of digital watchmakers is to sell the transparent interfaces to geeks, but to market more self-conscious, reflective designs to a public that may regard high technology as a part of fashion.

Now, too, the digital watch is marketed as a device for convergence. Companies are trying to find ways to put calculators, pagers, even e-mail readers and Web browsers in a form factor that we can strap on our wrists. By converging these technologies into a wrist-size package, they are creating information appliances that are really new media forms.

Meanwhile, others are developing another transparent technology, glasses, into wearable media forms. I-O Display with its I-glasses <www.i–glasses.com>, Sony with its Glasstron, and others are trying to convince users to wear their television sets. Again, they promise a transparent medium. But while the technology may strive to be transparent from the inside, it is conspicuous (and opaque) from the outside. The form factor is suitably futuristic—according a retro concept of the future that recalls the sleek designs of art deco and streamlining of the 1930s and 1940s (figure 5.5). (The wearer inevitably looks like Cyclops from the *X-Men* comics.)

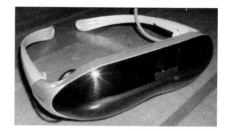

Figure 5.5
Sony Glasstron: a headset designed for consumers to watch television or have virtual reality experiences.

Although wearable computers take many forms, they all deliver media experiences. They are examples of the specific convergences of earlier media, and they are reflective as well as transparent. These devices are meant to be seen as well as seen through.

From information appliances to media forms

Wearable computers are closely related to the category of information appliance, which includes not only computing devices that we can wear but also ones that we carry in our hands and may put on the table in front of us. We have dated the history of information appliances from the introduction of the wristwatch, but we could also date it from the Sony Walkman in the late 1970s. This device is at the root of a ramifying evolutionary tree that now includes many forms of cassette, CD, and MP3 players. We could also start with handheld computers, of which the Palm Pilot was the great success story in the 1990s.

Don Norman regards the information appliance as the key to the future of computing. Like Mark Weiser and his ubicomp colleagues, Norman predicts that computers will spread throughout our environment and at the same time become invisible, concealed inside information appliances. The story of computers in the new millennium will resemble the story of the electric motor a hundred years ago. At first, you bought a general-purpose electric motor with various attachments. But as they were built into appliances such as vacuum cleaners, mixers, and drills, motors disappeared from our view and our conscious concern. So computers are being and will be built into individual devices, each designed to do one thing: organizers, electronic books, Web browsers, and so on (Norman, 1998).

Norman agrees that the future does not lie with one converged medium (certainly not a wall-sized interactive, high-definition TV). Each of his appliances converges some set of technologies to solve a single "information" problem. However, the future does not seem to lie exclusively with such single-purpose appliances either. These devices are proliferating, and some are becoming more specific. We now have electronic books that are designed exclusively for reading downloaded texts. An example is the Rocket Ebook, which refashions the features of the printed book, while also offering some hypertextual linking and annotation. There is, however, an opposite trend to combine more functions in a single appliance. The handhelds are experiencing feature creep because designers are trying to tie them into the Internet through wired or wireless connections. Recent versions of the Palm Pilot and other handhelds offer not only calendars, calculators, and notebooks but also e-mail programs and Web browsers.

These devices are not invisible computers; instead, their interfaces are often highly visible and reflective. The best designs are effective when they oscillate between being transparent and reflective, as the designers of the Palm Pilot understood from the beginning. The Pilot interface required handwriting recognition with a high degree of accuracy, but the technology was not sufficiently accurate if the user could write or print the traditional alphabet. The Pilot designers took the remarkable

Information appliances are not invisible computers with transparent interfaces; their interfaces are often highly visible and reflective.

gamble of requiring the user to learn a simplified alphabet, called Graffiti. This violated the principle of transparency in interface design, because it meant that users must adapt their writing to the machine; however, users were willing to make this adjustment. The shorthand

soon becomes transparent to the experienced user, in the sense that she no longer has to think about how to form the simplified letters. Even after it has become second nature to the user, however, the ability to write on a Palm Pilot remains visible to others. It marks you out as a new media adapter.

Like digital watches and mobile phones (and every other consumer product), handhelds are not designed simply to be invisible deliverers of information. The design strategy is expressed in the form factor as well as our interaction with the device. The slender and determinedly futuristic look of the handhelds constitutes part of the interface in the largest sense.

The computer industry had already learned this lesson with desktops. In the 1980s, Apple Computer's original Macintosh showed that the form factor was part of the interface, and Apple showed that again in the late 1990s with the bright plastics and retro-futuristic design of the iMac and G3 computers. The information appliances of today are no less visible than the desktops. In fact, they are more visible, because unlike the desktop computer, we often use our laptops and handhelds in public or quasi-public places: in an airport or on a plane, in a café, in a library.

Finally, as we have already noted, the so-called information appliances are usually media forms, and the term *appliance* does not work well for media forms. We don't call books, paintings, or photographs "appliances." We don't even think of television sets or radios primarily as appliances, because we don't apply them to solve problems. Instead, we experience them.

The mediascape

As it presents us with a welter of pseudo-information, *Fakeshop* serves as a parody of the media landscape in which we live. The whole SIGGRAPH conference is a microcosm of our mediascape. As we walk through the exhibits hall at SIGGRAPH 2000, we are bombarded with media forms competing for our attention. Touring the Art Gallery in particular, we see caricatures, parodies, and radical transformations of digital and earlier media. Information appliances, supposed by Norman to make the computer invisible, are visible all around us. They don't need to be concealed, as if they embarrassed us, as if they were "unnatural," because media are now a part of our world as much as trees, animals, and the other manifestations of nature. The purpose of digital design is to add in compelling and informative ways to the landscape of converging and diverging media devices.

Chapter 6. I-Garden

THE MATERIALITY OF NEW MEDIA

We are moving toward a philosophy of design that acknowledges both the place of computers in the world and the importance of the body and physical environment within and around the interface itself.

T-Garden

Before entering *T-Garden* in the SIGGRAPH Gallery, we dress ourselves in brightly colored robes that have sensors and audio speakers sewn into the fabric. When we walk into the dark space of the main chamber, we find the floor covered with transforming, polymorphous video- and computer-generated textures. In the words of its creators, the digital art group Sponge, *T-Garden* is a "responsive environment where visitors can put on sound and dance with images in a tangible way to construct musical and visual worlds 'on the fly.' The play space dissolves the lines between performer and spectator by creating a social, computational, and media architecture that allows the players to shape patterns in the dynamical environment" (*SIGGRAPH 2000*, 71).

Where we stand and how we move in the space of *T-Garden* changes what we hear and see (figure 6.1). And if we are not alone, our interactions with other visitors matter as well. Our location and our grouping can strengthen or lighten the density of the visuals and vary the sound space.

T-Garden is about the interaction of the physical and the virtual, of the virtual computational objects that manifest themselves in sound and video with the presence of the participants. *T-Garden* is like virtual reality in that it surrounds the user; its space resembles a VR cave. However, the designers of a VR cave are seeking to create the illusion of a world beyond

Figure 6.1
Sponge, T-Garden: *A dancer (Anne-Maria Korpi) interacts with the physical-virtual environment.*

its walls. What matters in *T-Garden* is the experience that participants make for themselves within the space bounded by the walls.

T-Garden is an experiment in experience design, showing how digital design can be physical and embodied. It is also an experiment in gesture recognition, as the system senses and responds to the visitor's motions. Visitors are participants whose embodied presence brings the space to life; they become part of the interface as they move around *T-Garden*. The point here is not to make the interface disappear, but rather to insist on the tangible nature of the interface.

Like *TEXT RAIN*, the interaction with *T-Garden* is a kind of writing. In *TEXT RAIN*, the participants write by interrupting the rain of letters as they fall. In *T-Garden*, there are no letters; the participants simply write with their bodies as they make gestures that leave visible and audible traces in the space. Like *TEXT RAIN*, the writing in *T-Garden* is ephemeral; the visible and audible traces fade. Like *TEXT RAIN*, the writing is vigorous and physical.

The participants in *T-Garden* are asserting their physical presence as they interact with the system. As they dance, they are defining a kind of embodied cyberspace. And so, like *TEXT RAIN* and other pieces in SIGGRAPH 2000, *T-Garden* questions another myth of the digital world: the myth of disembodiment, the belief that digital technology can (and should) allow us to divest ourselves of our bodies and enter a world of pure mind.

The myth of disembodiment I: Artificial intelligence

At the beginning of William Gibson's cyberpunk classic *Neuromancer* (2000), the nihilistic hero, Case, has been banned from cyberspace. "For Case, who'd lived for the bodiless exultation of cyberspace, it was the Fall. In the bars he'd frequented as a cowboy hotshot, the elite stance involved a certain relaxed contempt for the flesh. The body was meat" (6). If Case is any example, these cybercowboys go to considerable lengths to show their relaxed contempt:

they take a variety of drugs, drink excessively, and have sex with cyborg women whose implants pose hazards to continued enjoyment of the flesh.

In his peculiar way, Case is a contemporary fictional expression of a long prejudice against the body and against ways of knowing the world through our senses. The prejudice goes back at least to the Greek philosopher Plato, who argued that the world of the senses is a mere copy of an abstract reality. It was reinforced by Descartes in the seventeenth century, when he argued that certain knowledge could begin only when we removed ourselves as far as possible from the senses. This prejudice was picked up by the artificial intelligence movement, the dominant paradigm for understanding the computer from the 1950s to the 1980s. Artificial intelligence specialists defined intelligence as the logical manipulation of abstract data—manipulations that could be specified in an algorithm and "embodied" in a computer program running on a Turing machine. Even a few years ago, enthusiasts like Hans Moravec (1997) were still speculating how a human being's essence, his intelligence, might eventually be transferred from his body to a some sort of digital representation, which would then be immortal:

> Picture a "brain in a vat," sustained by life-support machinery, connected by wonderful electronic links to a series of artificial rent-a-bodies in remote locations, and to simulated bodies in virtual realities. . . . Why not use advanced neurological electronics like that which links it with the external world, to replace the gray matter as it begins to fail? Bit by bit our failing brain may be replaced by superior electronic equivalents, leaving our personality and thoughts clearer than ever, though, in time, no vestige of our original body or brain remains. . . . Our mind will have been transplanted from our original biological brain into artificial hardware. Transplantation to yet other hardware should be trivial in comparison.

This cyber-Frankenstein scenario is quite outdated. By 1997, virtual reality had replaced artificial intelligence as the paradigm of what computers can do. Moravec's prediction is doubly strange, because he himself builds robots, which are the tangible manifestation of artificial intelligence. Robotics is the attempt to embody artificial intelligence and make it active in our world—for practical purposes such as industrial processing and romantic purposes such as the exploration of Mars. Yet Moravec remains fascinated by the earlier paradigm—the myth of disembodiment that began with Plato. It is a myth from which the artificial intelligence movement never seems to escape.

At the end of *Neuromancer,* an artificial intelligence named Wintermute "takes over." Wintermute is a fictional version of what artificial intelligence specialists have been frightening us with since the 1960s: a programmed intelligence so advanced that it operates entirely on its own and for its own benefit. Wintermute is pure mind, and not surprisingly, it finds cyberspace to be its natural home. At the same time, Wintermute is so ephemeral that it cannot manifest itself outside the network. Although it is meant to represent the menace of ultimate power, in fact Wintermute seems almost benign, and benignly impotent. The main character Case has a conversation with Wintermute, who takes the form of a friend's face appearing on a wall-sized video display:

> "I'm not Wintermute, now" [the face says].
> "So what are you."
> "I'm the matrix, Case"
> Case laughed. "Where's that get you?"
> "Nowhere. Everywhere. I'm the sum total of the works, the whole show."

But when Case then asks, "So what's the score? How are things different? You running the world now? You God?" Wintermute replies: "Things aren't different. Things are things" (259). After that conversation, Case hardly ever catches a glimpse of this manifestation of pure mind, even when he returns to the cyberspace that he loves. The fact is that the Web sites Orbitz and Amazon.com have greater significance for the daily lives of millions today than Wintermute does on the inhabitants of Gibson's cyberpunk future, precisely because such sites are designed to reach beyond cyberspace into the embodied world.

The myth of disembodiment II: Cyberspace

By the 1990s, when the artificial intelligence paradigm was in decline, the coming of the World Wide Web provided new hope for those who still wanted to pursue the myth of disembodiment. For them, the Web seemed to be the realization of the cyberspace that Gibson had imagined in the previous decade. There was no need to wait (hundreds of years?) for artificial intelligence to create computer programs that could replicate our intelligence, if the Web could provide a place where we could individually and collectively escape the limitations of the flesh. In 1996, the U.S. Congress, with its typical clumsiness,

had attempted to limit pornography on the Web, which led John Perry Barlow to write his equally clumsy "Declaration of Independence for Cyberspace." Barlow told us that the Internet and Web had become a space beyond the reach of the laws and social practices of our physical world:

> Governments of the Industrial World, you weary giants of flesh and steel, I come from Cyberspace, the new home of Mind. On behalf of the future, I ask you of the past to leave us alone. You are not welcome among us. You have no sovereignty where we gather. . . . Our world is different. Cyberspace consists of transactions, relationships, and thought itself, arrayed like a standing wave in the web of our communications. Ours is a world that is both everywhere and nowhere, but it is not where bodies live.

Even if we sympathize with Barlow's position for freedom of expression on the Internet, we still must recognize that he was quite wrong about the disembodiment of cyberspace. Just as the computer itself cannot remain invisible, the cyberspace of the Internet and the Web is not and cannot be detached from the rest of the world. The Internet is important today precisely because it is integrated so tightly into our social and economic networks and our physical environment. The World Wide Web is not just a series of pages on our computer screens; it intersects in countless ways with our daily lives. We see URLs not only on television but in magazines, in telephone directories, on billboards, and even scrawled as graffiti on buildings.

Many of us work in businesses that exist because of the Web and that may close and leave us out of work when the value of the dot-coms falls in the cyberspace that we call the stock market. Cyberspace is continuous with our physical world: we order pizzas, cameras, and computer peripherals on the Web, and a delivery van pulls up in front of our house. Cyberspace is an extension of our social world as well—a new place for us to refashion who we are and who we want others to think we are. On the Internet, we represent ourselves to others through e-mail, chatroom conversations, and Web sites, and these digital postings are added to all the physical manifestations of our identity.

Just as the computer itself cannot remain invisible, the cyberspace of the Internet and the Web cannot be detached from the rest of the world.

Disembodied design?

Imagine that we are living in Hans Moravec's world. We have left our bodies behind, and our minds course through electronic networks, along with a host of artificial intelligences. Because these artificial intelligences are vastly more sophisticated than we are, we can only try our best to keep up. In this world, there is no need for visual design. We all speak in the language of symbols, and indeed everything important about the world is expressed in symbols. Vision itself becomes an algorithm for "pattern recognition" performed on digitized visual data. To human designers, this world of abstraction is anything but transparent. To the convinced artificial intelligencer, however, the world of symbols is a transparent representation of an underlying reality, uncluttered by the distractions of the body and even of the visual world.

This would be a world in which the logical structure of things shows through. It would be the contemporary (or almost contemporary) version of Plato's rejection of the physical.

Imagine that we are living in John Perry Barlow's cyberspace. People still have bodies, which they drag through the dull world of "flesh and steel," subject to the obsolete rules of national and local governments. But whenever they can, they rush to their computers to connect with the Internet, where they can live their real lives, freed of all markers of the body. They are no longer Europeans, or African Americans, or Asians; they no longer have brown or white skin, black or blonde hair; they are no longer fat or short or disabled; they are no longer men or women. They are all manifestations of pure mind and, at the same time, pure individuality; yet they are stripped of all the markers that make them individuals.

Both of these are extreme conceptions of how digital technology might remake our culture. Both subscribe to the myth of transparency, although they define transparency in different ways. For an enthusiast of artificial intelligence, arbitrary symbols can represent the world perfectly and transparently—not "natural" language, which is flawed and ambiguous, but an ideal language of thought, which computers and humans share (although computers can ultimately speak it more fluently). For Barlow, cyberspace is a transparent environment in which we can see through each other's bodies to the pure minds that live within. In both of these extreme visions, transparency and disembodiment go together.

Digital technology does not require disembodying the user, however. We are now moving in a direction different from both of these earlier visions. We are moving toward a philosophy of digital design (interaction design, sensorial design, experience design) that acknowledges both the place of computers in the world and the importance of the physical environment within and around the interface itself. Because the computer as a medium is part of our physical and social world, digital design must always be grounded in the appropriate physical and cultural environments. Because there can be no such thing as an abstract design (one that merely floats in Barlow's cyberspace), designers need to understand and care about the contexts in which their designs will function.

Because the computer as a medium is part of our physical and social world, digital design must always be grounded in the appropriate physical and cultural environments.

Visual art and design have never been pure, abstract, or removed from the physical. For many designers, the senses of sight and touch always go together, so that the world is seen and felt at the same time. This has been true in earlier media, including print, and it remains true in new media. Those who build digital interfaces and applications cannot escape from the physical world, for the obvious reason that digital design itself remains a physical activity. When the designer uses a mouse or a touchpad, rather than (usually in addition to) pencils or brushes, she gets used to how these tools feel. When she works at a computer monitor, she gets used to the adulterated colors that the monitor provides, and learns how to calibrate the monitor to get the best colors possible, just as the graphic designer has learned for decades to accommodate his design to the vagaries of color-separation printing. Designers working in any medium become viscerally aware of the capabilities and limitations of their tools. The computer too is a material medium, and the designer feels the process of design as a physical interaction with the medium. Repetitive stress injuries are a blatant reminder that digital workers cannot leave their bodies behind. Beyond that obvious fact, the digital designer seldom designs without making printouts, sketches, photographs, or physical models. This work requires a constant interaction between paper and electronic forms. Finally, digital design is material in the sense that the products, such as computer applications and Web sites, are materials that circulate and make a difference in our social world.

Digital artists in particular insist on the materiality of their work. They will never abandon or disparage the ways of knowing that the senses give us. For them, even the experience of seeing is not disembodied; it is visceral. Seeing is feeling. What fascinates digital artists are the ways in which their embodied existence is redefined in cyberspace. So they use digital technology to examine the interaction between the physical and the virtual. Every piece that we have visited in the SIGGRAPH Art Gallery explores that subtle and changing relationship. Digital design oscillates between the physical and the virtual, just as it oscillates between the reflective and the transparent.

Digital designers can explore the oscillation between the physical and the virtual in any technology, from desktop computers to wearables. Even the technology that seems dedicated to pursuit of the transparent—that is, even virtual reality—can be used to examine the nature of embodiment.

Virtual reality and embodiment

You are sitting in a Huey helicopter as it rumbles over a rice paddy in Vietnam. Your body vibrates with the roar of the engines. Machine-gun fire rattles in your ears. You look out the window and see the trees beyond the paddy, but you cannot locate the source of the fire (figures 6.2 and 6.3).

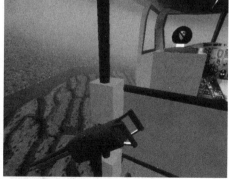

Figure 6.2
Larry Hodges, Virtual Vietnam: *Immersion and embodiment in a virtual reality application.*

Figure 6.3
Virtual Vietnam: *A view from the helicopter.*

This is not a movie but virtual reality. You are not in a darkened theater looking up at a movie screen; instead, you are wearing a VR headset (in the facilities of Larry Hodges's company, Virtually Better). Watching a traditional movie can be a compelling and even immersive experience, but as a viewer, you are in fact looking through a screen. In a VR application, you are wearing the screen, and the images of Vietnam surround you. The sounds are also immersive, coming from stereo headphones that you wear and from a subwoofer that vibrates to enhance the illusion. The result is a vivid simulation that might frighten anyone, but it can be terrifying (and physically real) to those whose experiences in Vietnam have led to posttraumatic stress disorder.

You are sitting in a darkened room wearing a VR headset. In this virtual Meditation Chamber, a voice in your headphones takes you through a series of relaxation exercises. You are asked to tense and then release the tension in various muscle groups in turn: first your legs, then your arms, shoulders, and neck. When you look down, you see a three-dimensional graphic representation of your body performing the tensing exercises as the voice describes them. You work to bring your physical body into synchronization with the interactive model (figures 6.4 and 6.5).

Virtual Vietnam and the Meditation Chamber show how virtual reality can explore the relationship between the physical and the psychological or the present and the past. When virtual reality entered the popular imagination in the 1980s, enthusiasts and critics represented it too as a technology to escape from our embodied world. Computer graphics would eventually be able to create images indistinguishable from the physical world, and designers would be free to create worlds limited "only by their imagination." The notion of escape pervaded

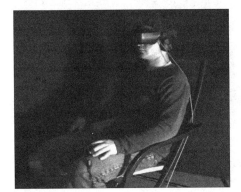

Figure 6.4
Diane Gromala, Larry Hodges, Chris Shaw, and Fleming Seay, Meditation Chamber: *An immersive environment provides users who are new to meditation with real-time feedback.*

Figure 6.5
Meditation Chamber:
*The user's physical
responses, via a
biofeedback device,
control the images.*

the whole rhetoric. In an article ironically entitled "No Interface to Design" (1991), interface designer Meredith Bricken, for example, described how virtual reality could free you from a single point of view defined by a single body: "You can be the Mad Hatter or you can be the teapot; you can move back and forth to the rhythm of a song. You can be a tiny droplet in the rain or in the river; you can be what you thought you ought to be all along. You can switch your point of view to an object or a process or another person's point of view in the other person's world" (372). In other words, when virtual reality was perfected (any day now), we would supposedly have the freedom to abandon our own bodily limitations and become another self, animate or inanimate. We would also escape from the world of texts, as Jaron Lanier, who coined the term *virtual reality*, told us. He claimed that virtual reality would usher in a world of "postsymbolic communication," in which people would share the same virtual world ("Virtual Reality Built for Two") where they would communicate by creating virtual objects.

Meanwhile, Hollywood films presented us with often nightmarish visions of the divorce between the physical and the virtual. For example, in *The Matrix* (1999), the characters live in a virtual reality that appears to be an American city in our own time. For most, the illusion is seamless: they live and die without ever suspecting the truth. In fact, their world is a "virtual reality built for millions" and bears no relation to the "real" world in which these same characters are kept, fetuslike, in vats and fed nutrients along with their diet of virtual images. The real world is the devastated remnant of our planet: both our physical environment and civilization have been ravaged. The contrast could not be greater. Nothing in their sometimes unpleasant late-twentieth-century existence can possibly compare with the horrors of the real world that is blocked from the characters' senses by VR technology.

Both the enthusiasts and Hollywood got it wrong. Creative VR applications do not seek escape from our embodied world: on the contrary, virtual reality can be a technology for

exploring embodiment. Simulators are almost the only commercially successful applications of virtual reality: flight simulators for airlines as well as simulators for piloting oil tankers or testing out new automobile control panels. Such simulators ask the user to develop skills that involve the hand and the eye as well as the mind and therefore require serious engagement with the physical world. The airline pilot's job and the passengers' safety depend on the training the pilots receive in simulators.

Creative VR applications do not seek escape from our embodied world; virtual reality can be a technology for exploring embodiment.

Virtual Vietnam is anything but an exercise in escape. Veterans who suffer from posttraumatic stress syndrome are asked to confront the experiences that led to their illness so that they can live more productively in this world. VR researchers are becoming increasingly interested in medical applications, especially for the treatment of phobias and pain management. Meanwhile, the Meditation Chamber belongs in the long tradition of meditation, which leads subjects to reimagine their relationship to their bodies in order to achieve a state of relaxation that is simultaneously and indissolubly psychological and physical.

Embodied design

Creative applications of virtual reality emphasize the close, though shifting, relationship between digital artifacts and our lived, embodied experience. We don't turn to our computers to escape from our bodies or our world. We can't escape, because we always take our identities formed by our embodied experience with us into cyberspace. The veterans who used Virtual Vietnam took their harrowing experience of Vietnam with them into the virtual environment, and that was precisely the point. Computers and their digital offspring are part of our world. We have chosen to place these devices, large and small, in our offices, homes, and automobiles. Although the space of light and sound that *T-Garden* offers seems at first new and strange, *T-Garden* is in fact a metaphor for the digitally mediated spaces that we inhabit today, in which desktop computers flash messages, cellular phones ring and vibrate, and automobiles honk or flash their lights reassuringly as we approach them (as if they were pets happy at our return).

As designers, we need to keep in mind that we are designing not for Gibson's cyber-cowboys but for embodied human users. In the era of artificial intelligence and the computer

as symbol manipulator, the computing community was not interested in the embodied user. Computers did not really possess interfaces prior to the work at Xerox PARC in the 1970s. The study of HCI began at that time, as computer specialists began to worry about how users as embodied creatures could interact with computer programs. The early HCI workers focused on the empirically measurable aspects of user interaction. They were interested in the human body for the limits of response by its senses, nerves, and muscles: how fast the user could press a key in response to a stimulus, what size icons the user could discern and click on, what color combinations the user could discriminate. Their approach was an outgrowth of the long tradition of ergonomics, the study of how workers use machines, or indeed how workers themselves could become machines. Like earlier ergonomics, HCI analysis looked for principles that could be applied to all humans considered as productivity units, not as human beings living under specific conditions and with specific concerns.

But HCI has changed radically since those early days and now understands the embodiment of the user in more sophisticated terms. Although some are still pursuing a vision of the computer as a tool for a pure virtuality, many researchers and software designers have come to realize that their users will not want to escape into cyberspace like Gibson's cowboys. They see that users will instead bring their computers into their social and physical world. Today, when software designers create an interface, they consider not only the interaction between a solitary user and a computer screen, but also the interactions between the user and her coworkers or colleagues. They develop technologies that integrate the computer into the world.

Mark Weiser's ubiquitous computing integrates the computer into the world by scattering computing devices throughout our environment. Another strategy is to combine our direct perception of the world with graphics provided by the computer. This strategy leads to augmented reality (AR) rather than virtual reality. In virtual reality, the user's view of the physical world is completely replaced by a world of computer graphics. The user typically wears eyepieces that completely block her view of her physical environment. In augmented reality, although the user may wear a headset, she can also see the physical world, because the eyepieces are (more or less) transparent. The computer lays its graphic images over the user's view of the physical world, augmenting that view. VR optics are opaque; the user cannot see the physical world at all. AR optics allow the user to "see through" into world. Ironically, it is virtual reality that (often) follows the Renaissance paradigm of the window, as it tries to

provide the viewer with a seamless view of the computer graphic world. Augmented reality is reflective. What the user sees—a combination of her physical environment and text or graphics that the computer draws—could not be mistaken for either the "real" world or a perfect imaginary world. It is a new paradigm in interface design (figures 6.6 and 6.7).

The user does not always have to wear the imaging equipment to experience this new paradigm. In versions of "mixed reality," the computer acknowledges the physical world by projecting information onto various physical surfaces. At the MIT Media Lab, for example, Hiroshi Ishii and his colleagues have created applications out of what they call tangible media, whose interfaces the user can both see and grasp <tangible.media.mit.edu>. Like Virtual Vietnam and the Meditation Chamber, Ishii's tangible media are experiments in

Figure 6.6
Blair MacIntyre, Augmented Reality
Construction Project: Assembling a strut.

Figure 6.7
Augmented Reality Construction
Project: The worker sees a combination
of the physical world and computer-
generated overlays.

embodied design that seek to engage with the physical world rather than deny it. The idea of pure virtual reality is losing ground to this mixed approach, as is also indicated by a recent issue of *Communications of the ACM* (July 2002), whose theme is "How the Virtual Inspires the Real." The issue describes research in collaborative augmented reality, virtual tools for eye surgery, virtual reconstructions on ancient archaeological ruins, and so on.

T-Garden is a mixed-reality application, in which computer-controlled light and sound are projected into and through a space. *T-Garden* illustrates that experience design is embodied design. To create digital experiences, we must engage the user-participant on a physical and visual as well as an intellectual level. For what experience in our human lives is purely cerebral? How could any experience be completely divorced from our physical being and still belong to us?

Imagine that we are living in a world of tangible media and mixed realities. We coexist in an easy relationship with virtual technologies, and we move in and out of cyberspace when we want. What we see and hear is a lively and changing combination of projected or interposed computer graphics and our physical surroundings. Our digital artifacts do not try to outthink us or separate us from our physical bodies. Sometimes they may be playfully unpredictable. We know, however, that the unpredictability was introduced by a human designer, whose goal is to engage our senses and our bodies more fully in the experience, as the dancer is engaged with the spheres of light in T-Garden.

As installation art like *T-Garden* (and *Fakeshop*) shows, the user's body is the first context that the digital designer must take into account. Digital art has led the way in looking at other contexts as well: the social and cultural contexts in which digital artifacts must also function.

Chapter 7. Terminal Time

DESIGN IN CONTEXT

Good digital design, like digital art,

can reshape its contexts

as well as respond to them.

Terminal Time

We wander out of the SIGGRAPH gallery itself, walk down one of the endless halls in the Morial Center, and enter a theater. It looks like a conventional movie theater, but when we sit down, the show immediately requires us to participate in an unconventional way (figure 7.1). On the screen, there appear multiple-choice questions, like this one:

> What is the most pressing issue facing the world today?
>
> A. Men are becoming too feminine and women too masculine.
>
> B. People are forgetting their cultural heritage.
>
> C. Machines are becoming smarter than people.
>
> D. It's getting harder to earn a living and support a family.

As we indicate our preferences by applauding, the familiar applause meter registers the collective response of the audience. We sense immediately that this is both frivolous and serious, as we try to read beyond the text to imagine the implications of our answers. Our audience answers three questions in this way and so identifies its ideology. We then watch a six-minute video that presents a breathtakingly swift summary of the history of the (Western?) world from 1000 to 1750 (figures 7.2 and 7.3).

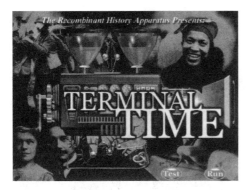

Figure 7.1
Michael Mateas, Steffe Domike, and Paul Vanouse, Terminal Time: *A pseudo-documentary that adjusts itself to the audience's ideology.*

This video is assembled so as to agree with the ideology that our audience has expressed by applauding. Then our audience answers three more questions and watches an almost equally fast tour of the years 1750 to 1950. Three final questions get us a positively leisurely six-minute presentation from 1950 to the present (figures 7.4 and 7.5).

Creators Michael Mateas, Steffi Domike, and Paul Vanouse describe *Terminal Time* as "a cutting-edge, audience-powered history engine that combines mass participation, real-time documentary graphics, and artificial intelligence to deliver the history that 'viewers deserve.' Each half-hour cinematic experience covers 1,000 years of history and is custom-made to reflect audience values and desires" (*SIGGRAPH 2000,* 57).

The presentations are not entirely serious. The videos look like file footage from a wacky local news station whose archives date back to the first millennium, and the narrative has the matter-of-fact,

Figure 7.2
Terminal Time: *Marching off to war in the Middle Ages.*

Figure 7.3
Terminal Time: *The causes of war in the Middle Ages vary depending on the audience's ideology.*

pseudo-objectivity of a Pathé newsreel. Nevertheless, *Terminal Time* is about cultural contexts and how they define our history. As we answer the loaded questions and watch the resulting video, we are ironically led to think about how our own reading of history is constrained by our cultural identities. Whether we are in the majority or minority in that particular audience, we get to see history being rewritten—for us or against us.

Like all other hypermediated digital pieces, *Terminal Time* oscillates between the modes of presentation and participation. When we watch the six-minute videos, we are in the role of spectators at a presentation, a role that we are accustomed to after decades of cinema. When we participate by answering questions registered on the applause meter, we are in a different, newer role. The experience isn't unfamiliar, however, because we play this role when we visit a Web site and are presented with a list of links to click. We play this role when we use a CD or DVD multimedia application, where we register our choices by pressing buttons.

The two roles require two different

Figure 7.4

Terminal Time: *One ideological reading of recent history.*

Figure 7.5

Terminal Time: *The atomic bomb defines one version of recent history.*

ways of looking: through the screen or at it. As spectators, we experience a more or less transparent movie. We see characters on the screen and enter into the action that we see. We can't enter in wholeheartedly, of course, because the videos are satiric and purposely amateurish. But we are not meant to think about the interface during the video segments; we are meant to experience the segments as we would a Hollywood film. As participants in the voting process, however, we are very conscious of the interface, and we are meant to reflect on our

participation in the vote—in particular, on the notion that our ideology is being tested. The experience is reflective.

Terminal Time has a user-centered design, in which our position as user is made obvious and even gently mocked. In this case, the user is an audience rather than an individual, and the design centers on the user's ideology. Terminal Time is making fun of any simplistic concept of the working of ideology, because obviously our complex of beliefs and prejudices, the frame through which we see the world, cannot be adequately measured through a multiple-choice test. Nevertheless, Terminal Time makes its point: that we always bring that network of beliefs and prejudices to any media form that we experience. Although new media cannot free us from those prejudices by testing them against an applause meter, it is also true that designers cannot afford to ignore their own ideologies or those of their users. Users bring cultural assumptions to each new media artifact, and they take the artifact (figuratively and sometimes literally) with them back into their cultural contexts. Digital art, especially digital installation art, heightens our awareness of those contexts.

Platonic design

Plato invented installation art. In fact, if there had been a SIGGRAPH 370 B.C., Plato's cave would have been the triumph of the Art Gallery. Plato's version was low tech in comparison to the VR caves of recent years, but it too was a participatory work, even if the participation was a bit masochistic. The subjects in Plato's underground cave would sit facing a wall, and they would be chained together so they could not turn their heads and look behind them. On the wall, they would see shadowy images acting out stories, and behind them would be a fire to cast the shadows, as well as men manipulating the shadow puppets. Actually, Plato's cave was like a VR cave in this respect. He wanted it to be so realistic that most viewers would think that the shadows were real. Plato believed that allegorically, this was the condition of most people: they spent their whole lives figuratively immobile and chained, believing in the reality of shadows. The film *The Matrix* updates Plato's idea of people enslaved by a perceptual technology.

Like *Terminal Time,* Plato's cave was also meant to expose assumptions. Plato believed that one extraordinary viewer might be able to free himself from his chains, turn around, and realize that what he saw on the wall was a shadow play. In fact, this extraordinary individual (the Platonic philosopher) eventually might be able to walk out of the cave

and see objects in the light of the sun. He might succeed in leaving the contexts of his companions (his society) behind and contemplate things as they are as a solitary philosopher.

The lesson of Plato's allegory is the opposite of the lesson offered by *Terminal Time*. For Plato, we are not defined by our cultural contexts ; instead, we (or at least a few extraordinary individuals) can stand outside all contexts and understand a higher truth. For the philosopher standing in the sunlight, there would be no shadows and no interfaces; the truth would be transparently obvious.

Almost 2,400 years ago, Plato made the case against cultural context. The best of all possible worlds, he thought, was one removed from the tainting influence of embodiment and even from the taint of human culture. Plato despised politics, just as, like a good Greek aristocrat, he despised the world of commerce. In fact, Plato believed that our embodied, everyday world was only a poor reflection of the real world, which for him was an invisible world of abstract ideas, or forms. This is the great Platonic reversal. It would seem obvious that the world of ideas depends on the world of the senses and culture, because people can't come up with ideas unless they are alive in this world and find themselves in a particular cultural milieu. But Plato reversed the dependency. He argued that the embodied world of human culture is a reflection of an invisible world of abstract ideas. Moreover, the amazing reversal became a major influence on ancient culture and later Western culture. The French philosopher Descartes in the seventeenth century reiterated this reversal and made sure that it would remain part of Western thinking into the twentieth century.

In this sense, many cyberspace enthusiasts are still Platonists. They replace Plato's world of forms with cyberspace, and then they divorce cyberspace from our embodied culture. Rather than understanding cyberspace as an extension of our culture, they see cyberspace as a separate and, in fact, better world. John Perry Barlow called cyberspace the "new home of Mind," suggesting that cyberspace is the higher reality, where we should really want to live. Who would want to spend time in the messy cultural politics of the embodied world, when we can shed our bodies and inhabit a space freed of the concerns of prejudice and economic scarcity?

The cyberenthusiasts may want their new digital medium to be divested of the many layers of cultural assumptions that we have inherited from the past. But we cannot free ourselves, even if we wanted to. Digital technology cannot take us to a place that is purged of cultural assumptions. Even when we go into cyberspace, we bring with us our cultural

assumptions—along with, and attached to, an image of our bodies. The traditions of artifical intelligence and the computer as a symbol manipulator still exert powerful influences to make designers forget or downplay the contexts of their designs, and digital art can help to counter-act those influences.

Digital art: Recalling the contexts

At SIGGRAPH 2000 and elsewhere, digital art works to reawaken our awareness of contexts. Art can respond to and reshape the physical context in which it is placed, just as *TEXT RAIN* does. *TEXT RAIN* turns a passageway in the Art Gallery into a space where passersby can interact playfully with an electronic text. Similarly, *Wooden Mirror* turns its exhibit area into a shared space in which its visitors strike poses and marvel at the resulting images. *T-Garden* converts a darkened room into a place in which participants can interact with sound and light. These pieces each provide us with an

Digital art works to reawaken our awareness of contexts.

embodied experience that also has social and cultural dimensions. They ask us to react playfully and to wonder whether it is appropriate to play in an art gallery. They help redefine our assumptions about how we behave toward art and, indeed, what art is in an era of digital interactivity.

Other pieces at SIGGRAPH make more direct attacks on some of our cultural assumptions—for example, *Exclusion Zone*. We already noted how *Exclusion Zone*, which presents us with microtexts printed on slides that we read by inserting into a microscope, asks us to rethink the act of reading. This unfamiliar act of reading is given both personal and political dimensions. To get to the microscope stations, we must walk over a map of Chernobyl, the site of the worst civilian nuclear disaster of all time. The texts we read describe the artist's own experience with thyroid cancer, which is often caused by exposure to radiation. We cannot remain aloof from these contexts. Chernobyl is all around us, beneath our feet, as we move across the exhibit. And when we pick up the slides, we are acting like biologists (or pathologists) examining specimens. Each time we want to read further in the artist's story, we must select a slide and focus it under the microscope. We are literally putting the artist's life under the microscope, with the supposedly detached scrutiny of a scientist. We act out the myth of scientific detachment.

It isn't just digital art that demands an awareness of context. All digital design is necessarily contextual and therefore reflective, in the sense that it reflects the culture in which it is created. Contextual design requires that we see ourselves as participants in the dance of our culture. Whether there are or aren't any atheists in foxholes, there should not be Platonists in digital design.

Computer software design: From Platonic design to HCI

We could call the decades before the work of Doug Engelbart and Alan Kay the Platonic era of software design. There was no emphasis on the points of contact between the user and the computer. The computer itself was hidden from its users, usually behind a service window in a large air-conditioned hall. The user brought his deck of punch cards to the window, and the operator fed in the deck and later returned him a printed output. It was as if users were consulting an oracle in an effort to communicate with a distant and disembodied god.

Such Platonic design eliminated all the supposedly unnecessary contexts. Computing was programming, and programming in this sense was the art of abstraction—stripping a problem to its essence. Programs written in this period typically devoted a tiny number of lines to input and output; the processing of the data occupied most of the code. The issues were how to develop compilers, programs for efficient numerical analysis, database management, and other forms of symbol manipulation. Once provided with data, the programs operated autonomously until they generated the desired output. It is no wonder that artificial intelligence experts conceived of the goal of

Platonic design eliminated all the supposedly unnecessary contexts. Computing was programming, and programming was the art of abstraction.

making computers completely independent of human operators—self-programming computers that could work like Cartesian egos without any need of the outside world.

The discipline of human-computer interaction, which grew up in the late 1970s, was a great leap forward in thinking about context (Badre 2002, 4–6). HCI was a response to the development of interactive computing systems, such as word processors. These systems worked through "event loops" in intimate contact with the user. As a result of this close connection, such systems had to take the user and her contexts into account. But at first, the

only context that HCI researchers considered was the individual herself. At this stage, HCI was almost a branch of perceptual psychology, concerned with the user's perceptual and motor skills. Then HCI experts began to regard the user as a "cognitive system" who formed a mental model of how the computer application worked. Later came the notion of user-centered design: when a new system was being developed, intended users should participate so that the system meets their needs. In other words, HCI experts kept expanding the contexts that they were willing to consider in digital design.

The discipline of human-computer interaction was a great leap forward in thinking about context.

Finally, in the 1980s and 1990s, some HCI experts and interface designers began to look beyond the individual to communities of users and the contexts in which they operate. Again, researchers at Xerox PARC, including John Seeley Brown and Paul Duguid (1994), led the way by considering how a proposed computer system might fit into the work environment. They would study the way an office worked before a computer system was introduced and then design the system to suit the needs of intended users. (For decades, programmers had simply built systems and thrust them into the office without bothering to find out what the intended users needed or wanted.) These office studies were among the first attempts to examine the contexts of digital designs.

Today, the World Wide Web makes designers aware of the need to consider cultural as well as work contexts (as Albert Badre shows us in *Shaping Web Usability*). A Web site is a digital artifact that is situated in an enormous variety of contexts. The Web itself is not really worldwide (there are relatively few users and even fewer sites in the developing world), but it does reach into many cultures throughout the industrialized world. And it can be used for a variety of purposes: e-commerce, personal expression, art, entertainment, and to support or oppose various political and religious ideologies. To design a good Web site or any digital application, the designer should try to understand as many of the contextual levels as possible: from the psychology of the individual user to the constraints imposed by the user's language, system of beliefs, and popular cultural knowledge. It is not just a matter of avoiding certain cross-cultural mistakes (e.g., using the wrong color or human gesture). Cultural awareness should inform the design process from the beginning.

Digital art and contextual design

In the previous chapter, we identified a new paradigm in computer design, pointing out how augmented and mixed reality and ubiquitous computing explored new relationships between the physical and the virtual. We can now give a name to this new paradigm: contextual design. Designing for and in context has been a principal concern of architects and visual designers since modernism, and increasingly it is a concern of interface designers as well. Augmented and mixed reality attempt to recognize the context in which digital artifacts operate—the lived world of human experience. The art of SIGGRAPH 2000 acknowledges the world of human experience, sometimes playfully, as in *Terminal Time,* and sometimes with the seriousness of *Exclusion Zone.* Digital design in general must take account of contexts in this same way.

That is not to say that digital applications must simply adapt themselves to the existing conditions of the user's world. Good digital design, like digital art, can reshape its contexts as well as respond to them. In fact, it reshapes contexts *by* responding to them. Digital art redefines contexts. *Terminal Time,* for example, seeks to remind us of the ways in which ideologies shape our telling of history. By making us aware of our ideologies, it will also aspire to

Like digital art, good digital design can reshape its contexts as well as respond to them.

change us—to make us less comfortable with our own dogmatic views. It will help us acknowledge the multiplicity of possible ways in which history can be written and read.

Any digital artifact—a productivity tool, a Web site, or even a computer game—is meant to change something in the user's relationship to her physical and cultural environment. Otherwise, there would be no reason to produce the artifact at all. In fact, an exemplary design not only takes account of its users' needs, but also identifies new users beyond any audience originally intended. This is the definition of a "killer app" (digital or otherwise): the telephone, the television, the word processor, and the World Wide Web all created new user communities by redefining the contexts of communication.

Chapter 8. The Art Gallery

OF

SIGGRAPH 2000

Digital art is about performance.
As users, we perform the design
just as we would a musical instrument.

The gallery as experience design

We leave the theater, where we've been applauding to the rhythm of our cultural prejudices with *Terminal Time,* and file back along the corridors of the Morial Hall, until we reach again the entrance to the gallery itself. We have examined individual pieces in the gallery, but not the gallery as a whole, which was designed and programmed to be an experience—part of and yet distinct from the experience offered by the rest of the SIGGRAPH conference.

Some conferences are events that the attendees sit through listening to papers and panels, but SIGGRAPH is a peripatetic experience. If, at any given hour, hundreds of name-tagged participants are attending paper sessions, thousands more are in motion, ambling en masse through the large exhibit and lecture halls or in single file along the corridors. The Art Gallery is a walk too; however, its dark pathway flanked by the exhibits is meant to encourage a more reflective pace. From the entrance, the visitor is invited to follow a gently curving path, more or less in the shape of the backward S. Certain exhibits, the ones the visitors are immediately drawn to, serve as anchor points, like data points fitted along the Bezier curves of the path (figure 8.1).

The space of the gallery is negative space, and like the concept of negative space in graphic design, the gallery gives meaning to the exhibits by enveloping, contextualizing, and relating them to each other. The whole gallery functions as a counterexhibit to the carnivalesque commercial exhibits. While the hall of commercial exhibits is flooded in the bright

Figure 8.1

SIGGRAPH 2000 Art Gallery: Some exhibits serve as anchor points along the visitor's path.

lights of transparency, the gallery, although large, seems almost intimate because of the black curtains that absorb the light and offer a contemplative space to the visitor. The gallery is about contrasts of light and dark. The whole space is as dark as the fire marshals would allow, with only neon signs to indicate the exits. The rest of the light is provided by spotlights that isolate various exhibits and by the electronic glow of the exhibits themselves (figure 8.2).

Although the gallery is no cathedral of art—reverence is not the desired tone—still the visitor is meant to experience the gallery, almost like a medieval cathedral, as a vertical space. Her gaze is led upward by the curtains that disappear into the forty-foot-high darkness. There are few horizontal lines to interrupt her view; instead, vertical banners are hung to mark out the exhibit, and at three places, giant projection screens draw her gaze along sightlines of the gallery. These projection screens look like heroic-sized paintings, except that the projected images are dynamic. The images are of Web sites, installed on computers below, and they change as the users visit different pages.

Walking along the path, we see how the pieces are arranged, often according to principles of contrast and similarity, which highlight their individual effects and at the same time contribute to the larger experience of the gallery. When the anchoring exhibits, like *Nosce,* draw us off the path, we notice other subtle pieces grouped around them. The reflective quality of some pieces, such as *Exclusion Zone,* needs a quiet, almost solemn atmosphere. Other pieces, like *TEXT RAIN* itself, can tolerate, and indeed thrive, amid the background noise of peripatetic visitors. Some pieces, like *TEXT RAIN* and *Wooden Mirror,* want

Figure 8.2
SIGGRAPH 2000 Art
Gallery: The lighting
of the gallery directs
visitors to the exhibits.

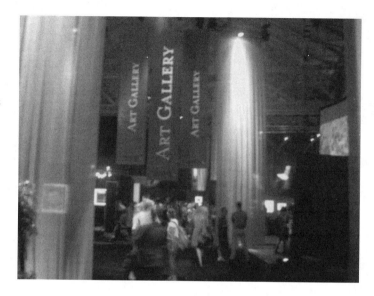

to be in the open, approached casually by visitors. Others, like *T-Garden* and *Exclusion Zone*, need their own enclosed space and controlled entrances. In these cases, drapes of black velvet are hung to create enclosures and cut down further on unwanted light and sound. The Web art is especially hard to integrate into the public experience of the gallery because Web sites are usually designed to be appreciated by a single individual in front of a relatively small monitor. In the gallery, computers are set up along the outer edges of the aisle to display the sites, and large video screens project what the individual user can see on the smaller computer screens. The projected Web sites become massive kinetic paintings that punctuate the negative space of the gallery and invite visitors to interact with the sites on a more intimate scale (figure 8.3).

The pathway of the gallery leads right into the Emerging Technologies (ETech) exhibits, and the works placed closest to ETech (such as *TEXT RAIN* and Richard Brown's *Biotica*) are the ones that most effectively blur the boundary between innovative technology and digital art.

Finally, the docents and artists themselves are present to help shape the experience that the gallery offers. Wreathed in fiber-optic lights, the docents circulate among the visitors (many of whom are not experts in art and design), explain the conventions by which these

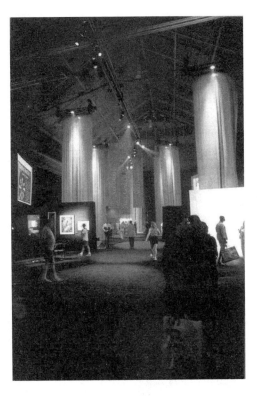

Figure 8.3
SIGGRAPH 2000 Art Gallery: The large
screen at the extreme right projects a Web site
and makes it part of the gallery experience.

digital pieces function, and suggest why certain pieces were chosen. The artists themselves clarify or perhaps debate their works. A further layer of explanation and debate is provided by artists' talks and panels that take the gallery beyond Hall D and into the conference rooms of SIGGRAPH 2000. Altogether, the gallery functions as a performance, or a series of performances, rather than a static exhibit.

Digital art is about performance, which is perhaps an even better word than *interaction* to describe the significance of digital design in general. As users, we enter into a performative relationship with a digital design: we perform the design, as we would a musical instrument. Digital artists and designers create instruments that the user will play. Sometimes the play may be as predictable as the music of a Hammond organ (where pressing one key produces an entire Viennese waltz). At their best, however, digital designs will enable their users to produce results unforeseen by their designers.

Digital art is about performance. As users we perform the design, just as we would a musical instrument.

The rhythm of digital design, the oscillation between transparency and reflection, is the rhythm of the whole SIGGRAPH Gallery. At times, the gallery is meant to disappear and leave the visitor alone with the pieces. At other times, the visitor is meant to be aware of the gallery as it puts the pieces into focus for her.

Digital focus

Film and television sometimes make use of a technique called rack focus: the camera shot begins with the background in focus and the foreground blurred, and then the focus shifts to the foreground, blurring the background (or vice versa). We see a character in the background looking with excitement at something in front of him. Then the character blurs, and we see clearly the object of his gaze. The technique of rack focus helps us to understand the meaning of that object for him.

In a sense, digital art translates the technique of rack focus into a new technology, framing and refocusing the meaning of digital design. The pieces in the SIGGRAPH Gallery are all ultimately about refocusing our vision. They ask us to look at the unexamined foreground or the unnoticed background. And experience design in general is the art of refocusing our vision as designers so that we can then refocus the vision of the end user.

Digital art reframes and refocuses the world of digital design.

In film and television, rack focus is not natural; it is a manipulation of our vision. The technique can be compelling because it makes us aware of the relationship between two elements in the scene, which we may not otherwise have appreciated. At the same time, rack focus makes us aware of the power of the medium of film. As a technique, rack focus is both transparent and reflective.

Digital art reminds us that we should approach every design task with the dual focus of transparency and reflectivity. Designers of digital experiences should always be conscious of the rhythm that the design establishes between its own transparent background and its visible, reflective foreground—between what is conventionally called the content and the interface that frames, focuses, and gives meaning to the content. The designer must embed the digital equivalent of rack focus into the design for the user to experience.

How does the designer do this? By taking into account the technological, historical, cultural, and economic dimensions of the media with which he or she is working—by remembering that:

- Experience design is remediating design: like *Magic Book,* it understands its relationship to earlier media forms.

- Experience design is diverse: like *Fakeshop,* it welcomes the multiplicity of digital media forms.

- Experience design is embodied design: like *T-Garden,* it recognizes how digital technologies seek to embody the virtual.

- Experience design is contextual design: like *Terminal Time,* it understands the importance of the cultural and economic contexts in which it will function.

By working with and through these dimensions, the designer can find the appropriate rhythm of transparency and reflectivity.

If we walk out of the Art Gallery and back into the general exhibit hall—into the carnival of booths offering us the latest in games, 3D graphics, Web design, and interactive technologies—we see that successful digital interfaces are ones that find such a rhythm. In every case, the designers have recognized when and how and to what extent to question the transparency of their designs. Computer and video game designers know how to create "cheats" that permit their users consciously to violate the rules (including the physics) of the games. Although productivity tools are often praised as being transparent to their task, such tools in fact shape the user's understanding of the task. Their success depends on the user's ability to work reflectively as well as transparently. That is, such tools must help users evaluate and manipulate the meaning of their work. Finally, the most successful digital consumer products are not merely transparent, but instead make the interface part of the experience, as Apple taught us with the original Mac in 1984 and again with the iMac in recent years.

The digital interface is always both a window and a mirror.

Chapter 9. Before and After

SIGGRAPH 2000

Designers cannot afford to ignore the need for transparency, but they can show the Structuralists how sites can be reflective as well as transparent.

The Structuralists and the Designers

On a morning in June 2002, designers all over America switched on their computers and must have been startled by the following news that flashed over the Internet from the User Experience 2002 Conference in San Francisco. The news was about Macromedia's vector-animation design environment Flash MX:

MACROMEDIA AND USABILITY GURU JAKOB NIELSEN WORK TOGETHER TO IMPROVE WEB USABILITY

Plan to develop best practices for developing rich Internet applications

User Experience 2002

San Francisco June 3, 2002

Macromedia, Inc. (Nasdaq: MACR) and Jakob Nielsen, Ph.D., usability guru and founder of Nielsen Norman Group, today announced a strategic relationship to focus on improving the usability of rich Internet applications and content. Nielsen will be developing best practice guidelines for creating usable rich Internet applications with Macromedia Flash MX. Macromedia Flash MX, which began shipping in March, contains features that enable designers and developers to be more productive while ensuring their work is both usable and accessible.

Designers who have lived and breathed Flash for years must have been struck by the irony, because Nielsen had scorned this application in the past. A Structuralist, Nielsen had

taken the iconoclastic position that Web pages should have as few images as possible, while Flash has been the Designers' favorite tool for creating visual experiences on the Web. It seems now that the lion is lying down with the lamb to create sites that are usable and visually rich at the same time. It remains to be seen who is the lion and who the lamb. Nielsen may not be able to tame what he regards as the dangerous (byte wasting) exuberance of visual designers, and the designers may not convince Nielsen of the importance of negative space. But even if this particular marriage of convenience turns into a banquet for one of the parties, it is a good indication that Structuralists and Designers are becoming more aware of the need to work together and that disciplinary and corporate barriers between the groups may be breaking down. The two groups need to work together precisely because they do not look at Web sites (or other digital designs or magazines or books) with the same eyes.

Don Norman too is beginning to emphasize this need. In "Emotion and Design" (2002) he complains that he has been misunderstood: he does not believe that *usable* and *ugly* are synonyms. Attractive things work better, he tells us, because users will overlook minor flaws in their artifacts if they are pleased by the appearance. He pronounces: "Let the future of everyday things be ones that do their job, that are easy to use, and that provide enjoyment and pleasure" (41). Still, Norman does not go far enough here. He is still conceiving of functionality and beauty as separate qualities, and seems to suggest that we can add beauty to an artifact as an afterthought, in order to put the user in a better frame of mind. The lesson of the SIGGRAPH Art Gallery is that good digital designs provide an experience that is both informative or functional and compelling at the same time.

Information architecture and experience design belong together, just as transparency and reflectivity go together in any digital application. Transparency is the key element for the Structuralists; they believe that a Web site or other digital design should transparently reveal its contents, the information it has to offer. Designers cannot afford to ignore the need for transparency, but they can show the Structuralists how and why sites can be reflective as well as transparent.

Designers cannot afford to ignore the need for transparency, but they can show the Structuralists how sites can be reflective as well as transparent.

We don't know whether Nielsen took the time to visit the SIGGRAPH 2000 Gallery or whether he has visited the galleries at the subsequent SIGGRAPH conferences. But digital art at the SIGGRAPH conference and elsewhere has continued to provide vibrant examples of radical design. Art continues to help us understand that information itself can be and should

be an experience, and every digital experience has, in a sense, information to impart. No matter how flashy, every digital design must convey a message to its viewer or user. Even the most businesslike information Web site should provide the user with a compelling experience. If Designers and Structuralists work together, the distinction between information sites and experience sites should disappear, although the various genres of sites will still offer different experiences and different forms of information.

The world of digital art

The SIGGRAPH 2000 Art Gallery was a snapshot, showing us a moment in the complex history of digital art. But it could not adequately represent that history as it has developed over the past twenty or more years. Nor could it encompass the creativity of the digital art world at the beginning of the new millennium. Indeed, this book could not even describe all the works in the SIGGRAPH 2000 Gallery (see the appendix for a complete list) or all the ways in which digital artists are collaborating with experience designers and information architects. At the SIGGRAPH conference itself in the years since 2000, the Art Gallery continues to show how digital art can be seen as an experiment in radical digital design.

> **The SIGGRAPH 2000 Art Gallery was a snapshot. It could not encompass the creativity of the digital art world at the beginning of the new millennium.**

In this conclusion, we want to convey a sense of the variety of digital art today by including some of the many artists who did not happen to participate in SIGGRAPH 2000 or whose work at SIGGRAPH 2000 we have not described in detail. Like those featured in previous chapters, these artists too are addressing the issues of reflectivity, remediation, diversity, embodiment, and cultural context, and so we present them here under those categories.

Mirrors and new media

Many digital artists are exploring the theme of reflectivity explicitly by creating pieces that (like *TEXT RAIN* and *Wooden Mirror*) reveal the viewer to herself or others through live or processed video. What the viewer sees in such interfaces may reflect the culture as well as the individual. Natalie Jeremijenko's surveillance system *Suicide Box* automatically captured the flight of human bodies from the Golden Gate Bridge over a hundred-day period and used the

results to produce a "despondency index" <www.yale.edu/opa/v27.n25/story9.html>. Elizabeth Diller and Ricardo Scofidio's *Refresh Project* <www.diacenter.org/dillerscofidio/intro.html> consisted of a set of twelve fictionalized, office Webcams, each with its own story to tell about American corporate and human relations. Natalie Bookchin's *Marking Time* <jupiter.ucsd.edu/~bookchin/marking_file/markingTime.html> placed the user in the role of a prison guard examining the faces of three inmates.

Remediation: The relationship of digital and other media

Digital artists and designers must all take into account both the old and the new in new digital media. For some, digital forms borrow and refashion older media forms in film and television. Others see the new digital medium as a technological revolution that will make possible new forms of storytelling, visual art, or audio art. Janet Murray is one who argues that interactive fiction is a new form, and she is particularly interested in a visual narrative that combines elements of film and artificial intelligence to control the appearance and behavior of virtual characters (Murray 1997). Lev Manovich <www.manovich.net> is an artist-theorist who reimagines visual technologies, in particular film, to define a "language of new media." Glorianna Davenport at the Media Lab produces experiments in interactive cinema <ic.media.mit.edu> that question the future of traditional, linear film.

Meanwhile, hypertext has been calling into question the future of the book and literature, an issue that engages, among many others, Johanna Drucker, Louise Sandhaus, and N. Katherine Hayles. Michael Joyce (*afternoon*), Stuart Moulthrop (*Victory Garden*), Shelley Jackson (*Patchwork Girl*), Talan Memmott (*Lexia to Perplexia*), and many others have fashioned hypertext into a new kind of literary fiction. At SIGGRAPH 2000 and elsewhere, Mark Amerika <www.markamerika.com> has exhibited his hybrid work *PHON:E:ME*, a Web-based piece that is "part oral narrative, part experimental sound collage, and part written hypertext" (*SIGGRAPH 2000,* 32). In the same way, Bill Seaman's *Recombinant Poetics* <oldcda.design.ucla.edu/faculty/seaman> and John Caley's digital poetry are attempts to define a new digital form of poetry that is active, interactive, and eclectic.

Telematic art, a form that dates back to the 1970s and was pioneered by Roy Ascott and others, makes a medium of expression out of transmission technologies such as video broadcasting itself. Networking and e-mail are refashioned into art forms such as cyberspace opera by the work of Madelyn Starbuck and others. In *Alive on the Grid*

<dolinsky.fa.indiana.edu/alive/apps/index.html>, Margaret Dolinsky combines networking and a VR cave to fashion a diverse, interactive art experience.

Video games and computer games are a form that draws on our expectations from film and print as well as traditional board games. Through interactivity, they seek to refashion the experience offered by these earlier forms. The SIGGRAPH 2000 Gallery offered an example of computer games as cultural comment in word.com's *SiSSYFiGHT 2000* <www.sissyfight.com>. Brenda Laurel <www.tauzero.com/Brenda_Laurel>, Eric Zimmerman (whose game *BliX* appeared also in the Gallery), Mary Flanagan <www.maryflanagan.com>, and many others have been expanding the form of the game to explore its potential for cultural expression.

Convergence and diversity

As we noted in chapter 5, digital media are not converging to a single form; instead, they are combining and recombining in many, more or less permanent, allegiances, and digital artists have been leading the way in exploring these allegiances. Almost every piece of digital art is a new convergence in this sense. The works of Diller and Scofidio, the telematic and network art by Ascott, Starbuck, Dolinsky, the collages of Seaman and Mark Amerika all exemplify the convergences of new media.

Because the World Wide Web is by nature an eclectic and hypermediated form, the whole field of Net art is an exploration of diversity. Rhizome.org, a site devoted to Net art, includes a piece featured at SIGGRAPH 2000, *Starry Night* by Alex Galloway, Mark Tribe, and Martin Wattenberg, which visualizes as a map of stars the popularity of various pages on the Rhizome site. There is Andruid Kerne's Web-based *Collagemachine,* a Web crawler (with a modernist aesthetic) that anticipates and visualizes the user's interests <mrl.nyu.edu/~andruid/ecology/collageMachine/>. There is Matt Owens's remarkable site *volumeone.com,* a collage of digital art forms and experiences, whose "Web novelties" test the limits of this media form. Noah Wardrip-Fruin, a. c. chapman, Brian Moss, and Duane Whitehurst offer us an "antibrowser," in their *Impermanence Agent* <www.siggraph.org/artdesign/gallery/S99/essays/noah.html>. The interplay of the virtual and physical is explored by George LeGrady's *Pocket Full of Memories,* in which visitors to the exhibit in the Pompidou Center scanned objects in their pockets, which then became part of the Web site <legrady.mat.ucsb.edu/pfom_lang.html>. *Riding the Net* by Christa Sommerer and Laurent Mignonneau <www.mic.atr.co.jp/~christa/> shows how digital art can offer insights into

interface design: this browser picks out appropriate images from the Web based on the user's oral remarks.

Sommerer and Mignonneau are among a diverse group of artists who are exploring another convergence: between digital media and the computational models of artificial life and artificial intelligence. Sommerer's and Mignonneau's artificial life environments include *Life Spacies II* and *PICO_SCAN*. Richard Brown <www.crd.rca.ac.uk/~richardb/> has created such pieces as *Neural Net Starfish* and *Biotica*. Featured in SIGGRAPH 2000, *Biotica* was "a visceral and immersive 3D experience of evolving, responsive, and abstract artifical life forms," in which users fly through the Biotica world using arm gestures" (*SIGGRAPH 2000*, 35). Pattie Maes at the Media Lab <pattie.www.media.mit.edu/people/pattie/> experiments with artificial life as well as artificial intelligence to build software agents, which serve practical purposes for Web searching as well as providing digital experiences. And in Rebecca Allen's *Emergence* system, users can define their own characters and objects in a three-dimensional artificial life world <emergence.design.ucla.edu/home.htm>. Is this user interface design or digital art?

Embodying the virtual

The relationship between the virtual and physical is one of the most pervasive subjects of digital art today. As we suggested in chapter 6, by examining this relationship, artists help to combat the myth of disembodiment.

At the intersection of the virtual and the physical, robotic art has been an important field for decades (Kac 2001). In recent years, Eduardo Kac and Ed Bennet have created the telerobotic bird *Ornitorrinco* and later the *Rara Avis*. Ken Goldberg and his collaborators planted the famous *TeleGarden,* which enabled people to water and tend plants over the Web. Simon Penny has made a series of pieces, in which viewers watch and interact with robots, including the playful *Petit Mal* <www-art.cfa.cmu.edu/Penny>. Stelarc created his *Robot Arm,* which controlled him as much as he and others controlled it, and Alan Rath's numerous robotic sculptures have made technology both the subject and the medium <www.hainesgallery.com/AR.statement.html>.

Some digital artists now perform and even dance in spaces that combine the virtual and physical (as indeed *T-Garden* invited users to dance with virtual forms). Yacov Sharir has performed simultaneously on a proscenium stage and in a VR world created in collaboration with Diane Gromala, entitled *Dancing with the Virtual Dervish: Virtual Bodies.* Media artist and

choreographer Thecla Schiphorst explored the "sensuality and anarchy of the act of touching and being touched" in *Bodymaps, Artifacts of Mortality* <www.telefonica.es/fat/eschip.html>. In *trajet: a video dance installation,* Gretchen Schiller and Susan Kozel have assembled a "dynamic and interactive space," in which "numerous screens … receive projected moving imagery, sound and light in synchronized sequences." Its interactivity brings attention to the users' movement through space, and in effect offers the bodily knowledge of dancers to nondancers <www.banffcentre.ca/wpg/Past_Exhibits/dgames>. Like several other virtual reality artists, Char Davies has redefined the immersiveness of virtual reality as a new kind of embodiment in her pieces *Osmose* and *Ephémère* <immersence.com/immersence_home.htm>. Stephen Wilson questions the myth of disembodiment in *Body Surfing* <userwww.sfsu.edu/~swilson>.

Many are using installation art to explore the architecture of hybrid virtual and physical spaces. Working with Jeffrey Smith and Phoebe Sengers, Simon Penny has created *Traces,* in which visitors leave virtual tracks of light as they interact in a highly mediated space of light and sound. In this vein too, Christian Möller's sonic and visual installations include *Virtual Cage* and *Audio Grove* <www.canon.co.jp/cast/artlab/pros2/pers-01.html>. In numerous pieces, Monika Fleishman and Wolfgang Strauss <maus.gmd.de/imk_web-pre2000/people/fleischmann.mhtml> have been exploring the aesthetics of digital space and insisting on the importance of embodied experience in the digital environment. And for the past ten years, Marcos Novak <www.centrifuge.org/marcos> has been examining how the digital realm redefines architecture.

Design in context

Never pure formalists, digital artists are inclined to ask how their art articulates with its own physical, cultural, and economic contexts. They use their art both to pose cultural questions and to suggest solutions.

Brenda Laurel, Mary Flanagan, and others have created video and computer games that correspond to the needs and affinities of girls, who are not traditionally encouraged to develop their computer skills. Artist and educator Victoria Vesna <vv.arts.ucla.edu> examines the physical and cultural contexts of the digital in both her art projects (such as *n0time,* which combines a Web site, a physical installation, and cell phone connections) and her writing. Indeed, she is coediting a book to be entitled *Context Providers: Conditions of Meaning in Digital Arts.*

Meanwhile, many artists are exploring the intersections of art and science—a cultural dialogue that Roger Malina has fostered and shaped for a generation in the journal *Leonardo*. Stewart Dickson <www.wmgallery.com/dick_395.html>, who created the kinetic sculpture *3-D Zoetrope* for SIGGRAPH 2000, shows how 3D information visualization (and in particular fractal mathematics) can be a new, materially realized media art form. Donna Cox <www.ncsa.uiuc.edu/People/cox> uses information visualization and 3D computer graphics in work ranging from abstract to ironic photorealism. Among his many pieces, Eduardo Kac is best known perhaps for his *GFP Bunny*, a genetically altered creature that glows green when exposed to certain light <www.ekac.org/gfpbunny.html>. The rabbit poses questions about the limits of art, the relationship of art and science, and the layers of cultural contexts that are wrapped around any artifact, especially a living being, that is claimed to be art. In addition to Kac, those working in the thriving fields of bioart and biotech art include Oron Catts and Ionat Zurr, who are exploring tissue culture and tissue engineering as a medium for artistic expression.

For many digital artists, art is a critical technical practice, a means of critiquing the assumption that technology is a tool to be applied to all social problems. In her interactive installations and performances, for example, Lynn Hershman Leeson <www.lynnhershman.com> questions our cultural roles and identities. As director of media and visual arts at The Banff Centre, Sara Diamond <www.banffcentre.ab.ca/mva/mvastaff/sara.htm> has fostered critical practices through conferences, exhibits, and publications, as well as through her own pieces, such as *Code Zebra,* software to define a collaborative game space on the Web. Teal Triggs, Liz McQuiston, and Sian Cook, founders of WD+RU, have developed numerous projects (such as the "conceptual typeface" Pussy Galore) that can be described as critical digital design practice. Sandy Stone <sandystone.com/sandystone.orig.html>, Joel Slayton <cadre.sjsu.edu/area210/Joel/joelbio.html>, Mark Pauline <www.srl.org>, and Natalie Jeremijenko also use their art to ask critical questions. Indeed, there is a dimension of cultural critique to the work of almost every artist we have mentioned.

For many digital artists, art is a critical technical practice, a means of critiquing the assumption that technology is a tool to be applied to all social problems.

Finally, many leaders in the design community have come to realize the importance of cultural awareness and cross-cultural sensibilities. Aaron Marcus has become a champion of cross-cultural interface design. Albert Badre recogizes the importance of culturally aware design in his book *Shaping Web Usability* (2002). And S. Joy Mountford <www.idbias.com/people.html> continues to do work that defies categorization (which is to say that she is appropriately diverse and eclectic for the era of digital media): she is designer, HCI expert, and artist in her work on contextually aware digital interfaces and applications.

Perhaps the most important program for shaping digital art has been the CAiiA-Star design Ph.D. program, directed by Roy Ascott <www.caiia-star.net> and integrating art, science, and technology. Its fellows and graduates constitute a global collegium, contributing to the understanding of digital art as contextual practice.

Colophon: Excretia

AND READING AS A
REFLECTIVE EXPERIENCE

In Excretia,
any text is both
a window
and a mirror.

Digital design must always provide users with an experience, even as it conveys information.

The design of this book

A colophon is typically a brief list at the end of a book of production-related facts, such as: the designer, typeface, compositor, stock, printer, and binder. We have more to say because we have tried to produce this book according to the principle that we have been preaching: to make it an experience that is both transparent and reflective. The layout of the book is not an afterthought. The visual design—the bold quotes at the beginning of each chapter, the hierarchy of fonts, the placement of images—is part of the meaning of the book. The body text of this book is set in Adobe Garamond, an old style typeface, whose goal is clarity (transparency). The headings are Univers and Dalliance.

Our design is not meant to be wholly transparent, however. Reading today is also a reflective experience, in which the medium (the letterforms themselves) matters. We wanted the design to encourage the reader to reflect on the contexts of this book (as both a printed artifact and a description of the world of digital design).

Excretia

The splash page at the beginning of each chapter incorporates an eclectic digital typeface called Excretia, designed by Diane Gromala. Actually, these pages can show only snapshots of Excretia letters, because this is a dynamic typeface, meant for display on computer screens and

wearable LCDs (liquid crystal displays), not book pages. On a computer screen, the characters would be constantly changing before the user's eyes. Excretia is a combination of various modern and postmodern typefaces: its uniqueness lies in its continuous morphing.

Excretia is also an algorithm, which determines how the letterforms will change as they are displayed to the reader. Although it is itself an expression of digital technology, Excretia has something in common with the calligraphy of the handwritten manuscript: how it looks and what it says can never really be separated. The letterforms in a text set in Excretia are never entirely transparent, as the shapes of the letters become part of the text itself.

This is an old idea. One thousand years ago, the Japanese understood the art of writing in the same way:

In the *eleventh-century* *Tale of Genji*, Genji is with his lover, Lady Murasaki, when he receives a letter from his prospective wife, the *Third* Princess. Murasaki doesn't need to read the contents of the letter. Once she glimpses the handwriting, she concludes that the girl will not be a threat to her. Genji is embarrassed by the childish writing. "You see" he says to Murasaki, "you have nothing to worry about." (2001, 558)

For the Japanese, calligraphic handwriting was not just a way to transmit messages. The style of the writing was integral to the message itself. Western culture promoted that idea of writing in the Middle Ages, but never perhaps as strongly as the Japanese did, and we lost it definitively with the triumph of the printing press. From the first, printed letters were extremely regular; every "a" looked almost exactly like every other. Printed texts, as visual texts, could not and still cannot express the personality of the writer. In fact, the writer is usually not the printer, and the writer usually has little or nothing to say over the choice of a typeface or the layout of his words on the page. The separation of writer, designer, and printer has guaranteed that the visual appearance of the book will not transparently express the author. So we look for the author's character in the choice of words themselves, not in the appearance of the text. Unlike the Japanese or Chinese or even Europeans before printing was invented, we are taught as readers to become "word processors"—that is, to ignore the texture and appearance of the texts that we read. Today only designers learn this other art of reading.

Digital technology seems to go even further than printing to distance us from the hand of the author, because algorithms produce the letters that we see on the screen. Digital letters displayed on a monitor are not even touched by the printer's hand. On the other hand, digital technology can help to reawaken our interest in the visual appearance of words. In the 1980s, the Macintosh gave the average user the power to choose her own typefaces and fonts and determine her own layouts. Through desktop publishing, the author could become the printer. Desktop publishing has led to some excruciatingly bad page design, but it has also educated a whole generation of writers to consider the visual dimension of their texts.

There are other ways in which digital technology could empower writing as an art of visual expression, because unlike printed letters, digital letters can change and morph under the eyes of the writer or reader. Such changes need not be random; they can happen in response to a stimulus, an input stream coming into the computer. This is how Excretia works. The writer is hooked up to a biofeedback device, which measures her heart rate, respiration, and galvanic skin response. As she writes, these continuous streams of data affect the visual character of the typeface. The words "throb" as her heart beats; they grow tendrils and spikes if she becomes "excitable." As the writer works, the text she has already written may continue to change, or she may choose to freeze it to reflect her state at the very instant of the writing—in effect, to create a biological-typographical record. The same words may have a very different feel, texture, and therefore meaning at different times. Excretia is the first in a type-style family Gromala calls biomorphic type (figure 10.1).

With Excretia, a word processor is no longer simply a productivity tool but a reflective experience in itself. As the writer works, he sees how his biofeedback reshapes his words. Galvanic skin response is also used in polygraph machines, and we could say that Excretia makes writing truthful in the ironic sense that it reveals the writer's bodily states. For the writer, Excretia is not only a visual experience; it invites the writer to take account of his body in the act of writing. He becomes literally aware of his autonomic states of heart

Figure 10.1
Diane Gromala, Excretia:
A typeface that responds,
in real time, to a user's
physical states.

rate, respiration, and galvanic skin response (figures 10.2 and 10.3).

A lie detector, however, is designed to extract a single meaning from its subject: whether he is telling the factual truth. (Lie detectors cannot really determine the truth, which is why they are not generally acceptable in court, but that is the premise under which they are used.) Biomorphic type does not attempt to generate a single meaning. There is no simple correspondence between the writer's condition and the moving image of his words on the screen, for the simple reason that heart rate and skin response are not under the writer's conscious and easy control. Furthermore, the meaning the user ascribes to his physical state is always changing, just as Excretia changes. Even if users try to manage their writing by controlling their respiration, unpredicted, "spiky" moments occur, in which the letters form interference patterns that are themselves vivid and almost pictorial (figure 10.4). Nevertheless, Excretia reflects the writer in a way that printed or static type does not. It offers a new interface between the text and its writer (and later readers as well). It reunites the act of writing with a physical awareness, a unity that the printing press denied.

Writing as a reflective interface

Writing has always functioned as an interface, even thousands of years before there were computers. Writing has been and is a visual interface between readers and ideas expressed in language. Prior to the

Figure 10.2

Excretia: *Through a biofeedback device, brainwaves drive changes in the font.*

Figure 10.3

Excretia: *The writer's heart rate causes the font to morph continuously.*

Figure 10.4
Excretia: *Galvanic skin response can create "spikes" in the font.*

computer, it was an interface powered by the individual human reader, who turns the text back into spoken or subvocalized language. With the computer, the task of powering the interface is now shared among the writer, the reader, and the computing system itself.

What kind of an interface is writing? In Western culture, writing has generally been supposed to be a window onto the world described by the language. Especially in the age of printing, with the exception of some specialty books, the letters and layout of the text were supposed to disappear. Obviously Excretia is different. Demanding to be seen and appreciated by the reader, Excretia belongs to the tradition represented by Japanese and some Islamic calligraphy and by the illumination of manuscripts in medieval Europe, in which words and images are inextricably joined.

Writing can also function as an interface between the writer and himself. Because the words that we put on a page or screen come from within us, they can tell us in some way who we are. Writing can be a reflective interface, a mirror of the author, although not a perfect mirror because our written identity is different from who we are when we are speaking casually. In fact, we have many written identities, as we write in different voices for different audiences and purposes. Like earlier forms of writing, Excretia is a reflective interface that reveals the author to himself—again, not a perfect or single reflection, but a myriad of refracting planes in the transpositions and changing angles of the letter forms. Excretia reflects a different part of the author's self.

Writing in the Western tradition is usually thought of as an exercise in abstraction. When a writer writes, she leaves her body behind and creates a version of herself that is abstract and reasonable—a Cartesian or even Platonic ego (although Plato supposedly dis-

dained writing). This notion of writing has survived into the computer age. We remember John Perry Barlow and other cyberenthuasiasts who wanted to stake out cyberspace as the realm of Mind. They were thinking of verbal e-mail, chatrooms, and MOOs when they claimed that in cyberspace, people could leave their bodies, their disabilities, and their prejudices behind. But that trick never works. Excretia insists that we cannot leave our embodied selves entirely behind when we enter cyberspace in any of its forms: e-mail, the Web, or even word processing. Along with so much of the digital art that we have been exploring, Excretia seeks to remind us of our bodies, and the self that Excretia reflects is a combination of symbolic writing and imagery—of abstraction and embodiment.

Materiality, embodiment, and the contextual in writing

Excretia is a digital system that insists on the physical nature of writing, because the writer's physical presence also leaves its mark on the writing. Historically, the notion we have had of the writer, especially "great" authors, has been just the opposite. Although they may be dying of consumption or alcoholism, their poetry or plays remain unaffected. Writing was supposed to be removed from such realities, but Excretia insists that we remember them. It insists on the physical contexts of writing. It monitors the writer's own bodily states as evidence of who the writer is at the moment of writing. By putting Excretia in printed form in this book, we also illustrate the theme of remediation: this digital typeface becomes an example of the ways in which new and old technologies can borrow from and refashion one another.

Finally, Excretia combines the two overarching visions of digital technology that we discussed in the first chapter: the computer as symbol manipulator and the computer as a manipulator of perceptions. Excretia does not deny the symbolic nature of writing. The writer still uses visible language to communicate. Instead, biomorphic type adds another layer of meaning to visible language by infusing the letters with a representation of the material and bodily nature of writing. It foregrounds the material side of writing that had been downplayed and even suppressed in centuries of printing and in the first decades of computing.

The reader of a text written in Excretia—whether it is the author or a later reader—oscillates between reading the text in the traditional way and appreciating the letterforms themselves. The letterforms have their own message to convey. This is another example of the oscillation between transparency and reflectivity. Written in Excretia, any text is both a window and a mirror.

Aesthetics and Computing Group, MIT Media Lab
The Introspection Machine

(art)n Laboratory
Townhouse Revisited

Mark Amerika
PHON:E:ME

Laura Beloff and Markus Decker
HAME

Kathleen Brandt
Exclusion Zone

Richard Brown
Biotica

Lois Burkett
MOMENT (#1)

John Chakeres
25 Palmer

Todd Childers
POO3279723

Sarawut Chutiwongpeti
Utopia1997

Stewart Dickson
3-D Zoetrope

Elliott Peter Earls
EYE SLING SHOT LIONS

Fakeshop
Lifescience-Fakeshop

Nan Goggin, Mick Brin, Joseph Squier, and Robb Springfield
Insideout

Hunter Grant
Liberation

Bill Hill
The Black Lung

Rania Ho
Free Range Appliances in a Light Dill Sauce

Tiffany Holmes
Nosce Te Ipsum

Kenneth A. Huff
99.8A

Franklin Joyce
REMEMBER WHEN WE THOUGHT TELEVISION WAS FLAT AND THE CENTER OF THE UNIVERSE

Jeff Knowlton
A Text for the Navigational Age

Mark Korn
A Flinching Mind

Kumiko Kushiyama and Sinji Sasada
Hide-and-Seek

Liz Lee
Identification—Analyze

Jennifer Ley
Daddy Liked His with Heart

Jessica Maloney
The Eyes Grow Dark

Jacquelyn Martino
Hangman: Is There an "I"?

Michael Mateas, Steffi Domike, and Paul Vanouse
Terminal Time

Yasushi Matoba and Hiroshi Matoba
Micro Friendship

Kelly McFadden
Los Hermanos de Destruccion Numbero 6

Conor McGarrigle
Spook . . .

Mark Millstein
Tall Sumac Kite

Bonnie Mitchell
Merging Identity: Exploration of Identity: The Body and Life Online

Marjan Moghaddam
Adoration of the Gas Tank

Norie Neumark, Maria Miranda, Richard Vella, Greg White, and David Partolo
Shock in the Ear

Plancton Art Studio
Relazioni Emergenti

Thomas Porett
TimeWarp-Philadelphia

Rhizome.org
StarryNight

Daniel Rozin
Wooden Mirror 1999

Philip Sanders
NYC Night/Samurai

Jim (Aristide) Scott
Consume 2

Sponge
M3: T-Garden

Jack Stenner
Satisfaction

Andrew Stern
Virtual Babyz

Igor Stromajer
SM-N

Piotr Szyhalski
Die Zeitstücke (Timeworks)

Michele Turre
Neoclassic, From Tired Landscapes

Anne Ulrich
The Siren

Camille Utterback and Romy Archituv
TEXT RAIN

Kimberly Voigt
Digital Jewelry Explorations

VRML-2000

Noah Wardrip-Fruin, a. c. chapman, Brion Moss, and Duane Whitehurst
The Impermanence Agent

Annette Weintraub
CrossRoads (Wonder: Suspended in Air)

Word.com
SiSSYFiGHT 2000

Guan Hong Yeoh and Yulius
The H.E.A.R.T. of Stone

Jen Zen (Jennifer Jen Grey)
Final Spin

Eric Zimmerman
BLiX

References

Alberti, Leon Battista. 1972. *On Painting and on Sculpture: The Latin Texts of De Pictura and De Statua.* Trans. and ed. Cecil Grayson. London: Phaidon.

Alpers, Svetlana. 1983. *The Art of Describing: Dutch Art in the Seventeenth Century.* Chicago: University of Chicago Press.

Apple Human Interface Guidelines: The Apple Desktop Interface. 1987. Reading, Mass.: Addison-Wesley.

Badre, Albert N. 2002. *Shaping Web Usability: Interaction Design in Context.* Reading, Mass.: Addison-Wesley.

Barlow, John Perry. 1996. "Declaration of Independence for Cyberspace." <www.eff.org/~barlow/Declaration-Final.html>. Accessed June 30, 2002.

Berger, John. 1972. *Ways of Seeing.* London: Penguin.

Bricken, Meredith. 1991. "No Interface to Design." In Michael Benedikt, ed., *Cyberspace, First Steps,* pp. 363–382. Cambridge, Mass.: MIT Press.

Brown, John Seeley, and Paul Duguid. 1994. "Borderline Issues: Social and Material Aspects of Design." *Human Computer Interaction* 9,1 (Winter): 3–36.

Casamayou, Maureen Hogan. 1993. *Bureaucracy in Crisis: Three Mile Island, the Shuttle Challenger, and Risk Assessment.* Boulder, Colo.: Westview Press.

Cortada, James W. 1996. *Information Technology as Business History: Issues in the History and Management of Computers.* Westport, Conn.: Greenwood Press.

Cortada, James W. 1997. "Economic Preconditions That Made Possible Application of Commercial Computing in the United States." *IEEE Annals of the History of Computing* 19,3:27–40.

Gibson, William. 2000. *Neuromancer.* New York: Ace. [originally published 1984]

Gombrich, E. H. 1961. *Art and Illusion: A Study in the Psychology of Pictorial Representation.* Princeton, N.J.: Princeton University Press.

Hiltzik, Michael. 1999. *Dealers of Lightning: Xerox PARC and the Dawn of the Computer Age.* New York: Harperbusiness.

Hodges, Andrew. 1983. *Alan Turing: The Enigma.* New York: Simon & Schuster.

"How the Virtual Inspires the Real." 2002. *Communications of the ACM* 45,7 (July).

Johnson, Scott. 1999. *Inside TMI: Minute by Minute.* <www.wowpage.com/tmi/>. Accessed July 1, 2002.

Kac, Eduardo. 2001. "Robotic Art Chronology." *Convergence* 7,1 (Spring): 87–111.

Kay, Alan, and Adele Goldberg. 1999. "Personal Dynamic Media." In Paul Mayer, ed., *Computer Media and Communication: A Reader*, pp. 111–119. Oxford: Oxford University Press.

Landes, David. 1983. *Revolutions in Time: Clocks and the Making of the Modern World*. Cambridge, Mass.: Harvard University Press.

Laurel, Brenda. 1991. *Computers as Theater*. Reading, Mass.: Addison-Wesley.

Licklider, J. C. R., and Robert Taylor. 1999. "The Computer as a Communications Device." In Paul Mayer, ed., *Computer Media and Communication: A Reader*, pp. 97–110. Oxford: Oxford University Press.

Meggs, Philip B. 1998. *A History of Graphic Design*, 3rd edition. New York: Wiley.

Moravec, Hans. 1997. "The Senses Have No Future." <www.frc.ri.cmu.edu/~hpm/project.archive/general.articles/1997/970128.nosense.html>. Accessed June 30, 2002.

Murasaki, Shikibu. 2001. *The Tale of Genji*. Trans. Edward G. Seidensticker. New York: Alfred A. Knopf.

Murray, Janet. 1997. *Hamlet on the Holodeck*. Cambridge, Mass.: MIT Press.

Nelson, Theodor H. 1984. *Literary Machines*. Theodor H. Nelson.

Nielsen, Jakob. 2000. *Designing Web Usability*. Indianapolis: New Riders.

Norman, Donald. 1998. *The Invisible Computer: Why Good Products Can Fail, the Personal Computer is So Complex, and Information Appliances Are the Solution*. Cambridge, Mass.: MIT Press.

Norman, Donald. 2002. "Emotion and Design: Attractive Things Work Better." *Interactions* 9, 4 (July–August): 36–42.

Rheingold, Howard. 1991. *Virtual Reality*. New York: Simon & Schuster.

Shedroff, Nathan. 2002. "A Unified Field Theory of Design." <www.nathan.com/thoughts/unified/>. Accessed June 30, 2002.

Siegel, David. 1997. *Creating Killer Web Sites*, 2nd ed. Indianapolis: Hayden Books.

SIGGRAPH 2000: Electronic Art and Animation Catalog. 2000. New York: Association for Computing Machinery.

Tognazzini, Bruce. 1993. "Principles, Techniques, and Ethics of Stage Magic and the Application to Human Interface Design." In *Proceedings of the Conference on Human Factors in Computing Systems 1993, Amsterdam, The Netherlands (April 24–29, 1993)*, pp. 355–362. Reading, Mass.: Addison-Wesley.

Tschichold, Jan. 1998. *The New Typography*. Trans. Ruari McLean. Berkeley: University of California Press. [original German publication 1928]

Turkle, Sherry. 1984. *The Second Self*. New York: Simon & Schuster.

Walker, John. 1990. "Through the Looking Glass." In Brenda Laurel, ed., *The Art of Human-Computer Interface Design*, pp. 437–444. Reading, Mass.: Addison-Wesley.

Weiser, Mark. 1991. "The Computer for the 21st Century." *Scientific American* 265, 3 (September): 94–104.

Williams, Raymond. 1975. *Television: Technology and Cultural Form*. New York: Schocken Books.

Winograd, Terry, ed. 1996. *Bringing Design to Software*. Reading, Mass.: Addison Wesley.

Wurman, Richard Saul, and Peter Bradford. 1996. *Information Architects*. Zurich: Graphis Press.

Zimroth, Evan. 1993. *Dead, Dinner, or Naked: Poems by Evan Zimroth*. Evanston, Ill. Northwestern University Press.

Index